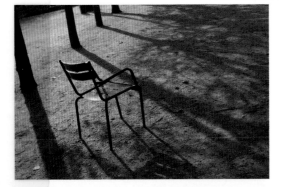
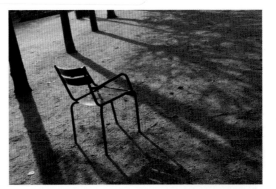
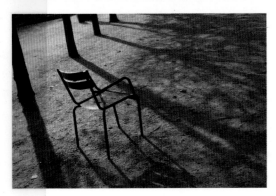

printing
for digital
PHOTOGRAPHERS

printing
for digital
PHOTOGRAPHERS

TIM DALY

First published 2008 by
Photographers' Institute Press
an imprint of The Guild of Master Craftsman Publications Ltd,
166 High Street, Lewes, East Sussex BN7 1XU

ISBN 978-1-86108-528-3

Production Manager: Jim Bulley
Managing Editor: Gerrie Purcell
Project Editor: Rachel Netherwood
Managing Art Editor: Gilda Pacitti
Design: Nina Daly

Typefaces: Stempel Garamond and Helvetica Neue
Colour reproduction by GMC Reprographics
Printed and bound in China by Sino Publishing

Contents

INTRODUCTION

With print quality and ink permanence at an all-time high, there's never been a better time to get into digital printing.

With the rapid turnaround in technology that we have seen in the last three years, professional photographers are more keen than ever to take control of their output. Despite the price tag of a good quality desktop inkjet, photographers who would otherwise send work to a photo-lab can now increase their profitability with a modest cash outlay and a little extra production time.

Excellent quality desktop printers are made by Epson and Canon, both now forging well ahead of the competition and firmly established as the professionals' chosen brands. Both manufacturers have designed precision printers in a range of sizes, supported by printer software, which makes the act of printing a straightforward and uncomplicated process.

The developments in digital printing hardware have enabled users to create pin-sharp prints that are indistinguishable from conventional silver-based prints, and all from the convenience of a desktop.

Yet, despite this streamlining of workflow, it is still essential to understand how to get the best out of the equipment and how to avoid wasting valuable consumables. The golden rule is not to skimp on the quality of your materials.

Never compromise print quality by using inferior, third-party inks and avoid the cheaper brands of inkjet paper, as they contain all manner of chemicals just waiting to disintegrate over time.

WHAT CAN I PRINT?

Unlike conventional silver-based photography where there were few options on the type, size and style of output, digital printing offers an enormous range.

Digital image files are the most versatile forms of visual information ever invented, able to be converted and distributed around the world in a matter of minutes.

With a well-exposed digital file, you can transform it into a multitude of formats for email, print, screen display, sale, presentation and an expanding range of on-demand products such as books, textiles and promotional material.

Image processing software such as Photoshop and Lightroom have developed considerably to support the expanding need for print-out and provide precise tools for formatting work to fit into your desired form. Images can easily be transformed into many different variants, from stunning colour to evocative monochrome, adopting all the sensitivity and appeal of conventional hand-made photographic prints. Photographers armed with a good broadband connection, a modest PC and a stack of great images can

start trading their wares over the internet, linking into micro-stock libraries or distributing their photo-books through online resellers.

At the heart of *Printing for Digital Photographers* is guidance, so you can carry on with being creative and not get bogged down with the technical process.

Hardware
and media

COMPUTER WORKSTATION

Choosing the right computer workstation will make all the difference between enjoyment and frustration. Yet with prices dropping and specifications rising, there are good systems available to suit all budgets.

Professional workstation

A professional Apple desktop system is designed to support memory intensive applications such as Adobe Photoshop. With ultra-fast processors and speedy graphics cards, this kind of workstation won't hold you back. The latest Apple Macs use Intel processors and can run Microsoft Windows as well as the native Mac OS X.

All-in-one

Workstations such as this Apple iMac save space, but without compromising on performance. The iMac is a well-established brand, designed to support photo-imaging, with conveniently placed USB and Firewire ports for easy data transfer from your digital camera. All-in-ones offer good value, but have less facility for upgrading compared to a professional desktop system.

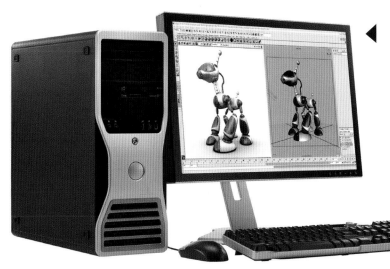

Windows PCs

High specification Windows-based computers are generally designed for 3D design and gaming. Opt for as much memory and the largest flatscreen monitor that you can afford. A basic, home office PC will still run Photoshop, but at a snail's pace.

Data storage

Planning how to store your digital data is an essential part of setting up a system. A cost-effective solution is to buy a system with a DVD writer, either built-in or external, and archive your files on DVD-R disks.

Hints *and* Tips

Today's modern laptops are just as good as desktop systems for photo-imaging. With professional models small enough to fit inside a camera bag, laptops offer the chance to edit on location. Apple MacBook laptops have large, bright screens that are easy to use outdoors. Once back in the studio, most laptops can also be connected to a normal monitor, so you can edit on a grander scale.

MONITORS

The most important piece of equipment in an imaging workstation is the monitor. Invest in the best quality product that you can afford and spend time setting it up properly before you start printing out. Using an uncalibrated monitor is like having coloured photo filters permanently attached to your camera lens.

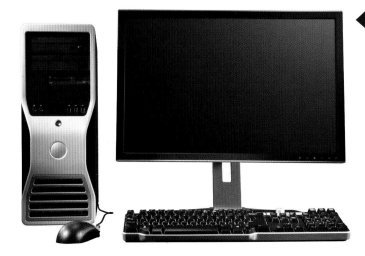

Professional TFT monitor

A high-specification monitor like this Dell product offers you the ability to work at super-high resolution. Latest models are much brighter than earlier thin film transistor monitors and are easier to use than the bulbous cathode ray tube monitors.

Although professional monitors can display images at high resolution, displays configured above 1600x1200 pixels can make it difficult to view small tool icons in Photoshop. Set the display at a comfortable setting, so you can work for a couple of hours without straining your eyes. For best quality results, set the monitor to display Millions of Colours, as this will ensure you see every single different colour in the image.

Multiple monitor output

Many professional imaging applications like Adobe Photoshop and Apple's Aperture, shown below, allow you to display the desktop on two separate monitors. This gives you the chance to view the image document on one screen, while keeping tools and dialogue boxes on another.

Desktop colours

It's essential to eliminate all possible influences when it comes to judging colour onscreen. Avoid the temptation to use highly patterned or strongly coloured desktop designs as this will impair your ability to judge any colour imbalances in an image. A deep yellow surrounding desktop will make your images appear more yellow than they really are. Set a neutral grey desktop colour and you'll be able to see casts much better. Finally, position your monitor away from strongly coloured walls and bright lights, especially fluorescent tubes.

15

PRINTER TYPES

There are so many different models available it can be difficult to choose the right kind of printer for your workstation. Many models offer light-fast ink so you can be assured that your desktop prints will last a lifetime.

Desktop inkjet ▶

The cheapest kind of colour printer is the desktop inkjet, as found in most supermarkets and electrical retailers. This kind of device creates prints from four different colours such as cyan, magenta, yellow and black, but will not print out photo-realistic results.

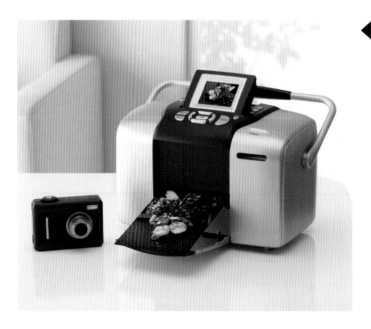

◀ Portable printers

A recent innovation is the portable printer, capable of making postcard-sized prints while out on location or in the studio. Like Polaroid proofing film, the portable printer provides the photographer a quick and efficient way to make prints by connecting the camera direct to the device through a USB lead. Better models are fitted with an LCD preview screen.

Professional pigment ink printer ▶

The best kind of output is achieved from a professional inkjet printer using fade-resistant pigment ink. For professional photographers, it's essential that any printed matter is lightfast and pigment inks provide at least 100 years of stability. Epson's K3 Ultrachrome inks offer excellent results; these are available in eight or nine colour configurations, including black inks of different density, and are suitable for matt or glossy paper media.

Photo-quality printer ▶

Good quality output can only be achieved from a specialist inkjet photo printer, fitted with six or more different coloured inks. With additional light magenta and light cyan colours, this kind of device can mimic the subtle tones found in a traditional photographic print. Available in A4 and A3 sizes, this is an ideal starter for a keen photographer.

PHOTO PRINTERS

Designed to provide fine quality prints from a range of different paper materials, the photo quality printer is an essential part of a photographer's workstation. Many models use eight or more different ink colours and results are indistinguishable from traditional photographic prints.

◀ Professional printers

Built to withstand repeated use in a studio environment, models like the Epson 2800 are rugged and reliable. Fitted with eight individual inksets, this printer uses an innovative range of colours including three different densities of black. Most professional devices can output up to A3+ with an additional manual paper loading source, for feeding in the largest and thickest media without bending.

◀ A2 inkjets

For a really special piece of equipment, a professional A2 printer offers the chance to output your work on an exhibition print scale. Better models are built with high capacity paper trays and a permanent roll paper feeder.

◀ Proofing-style printers

With the same internal mechanisms as a professional inkjet, this device offers the extra facility to output onto roll media, including fabric and plastics. Used by graphics studios, the Epson 4800 is high speed and has high volume pigment ink cartridges, typically 200ml or more. The only downside is the cost of a full set of replacement inks, which can be as much as 40% of the original price of the printer.

HOW PRINTERS WORK

All desktop inkjet printers are designed to produce prints that mimic the look of a conventional photograph. If you want to get the very best results out of your printer, it's important to understand how it works.

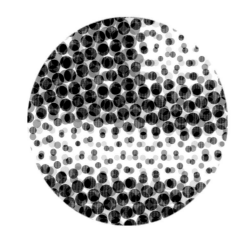

How colour is mixed

Inkjet printers produce photo-realistic prints by spraying fine dots of ink onto receiving media. The two dominant brands of printer, Canon and Epson, use slightly different mechanisms to deliver ink, but the principles are similar. Ink is held in pressurized containers and is forced onto receiving media in variable-sized dots. When viewed from a distance, these tiny individual specks of colour merge together to give the impression of continuous tone. The process by which these dots are arranged and distributed to create an illusion is called dithering. This example, above left, is a magnified area of an inkjet print, showing the individual ink dots creating an illusion of continuous colour.

20

▲

Printer resolution and image file resolution

Although the manufacturer may claim a printer can output at 1440, 2880 or even 5660dpi (dots per inch), these are not separated dots, but overlapping ones. The true resolution of the device is usually about 240 dots per inch, per colour. When multiplied by the number of different ink colours, this gives the true resolution of the device. Typically, the true resolution of a six-colour printer is 1400dpi (6x240=1440). Higher specification devices offering 2880 or higher are able to do this by spraying an additional half-size (or quarter-size) dot, thereby increasing the resolution. When preparing an image file in Photoshop for output to an inkjet, it needs to be no higher than 240ppi (pixels per inch).

Getting best print quality ▶

Best print quality is achieved when a high-resolution image file is delivered to the paper using the right combination of printer software settings. Most good quality printers are bundled with versatile printer software, which offers you a range of settings to get the best out of your chosen ink-and-paper combination. Start by selecting the closest description of your media in the Print Media dialogue, for example photo glossy, photo matt or archival matt. Next, choose the highest available resolution, such as 1440, 2880 or higher.

21

DIGITAL SLR CAMERAS

With specifications rising and prices falling, there is a good quality digital camera to fit most budgets. The more expensive a digital camera is, the bigger pixel dimension it can create.

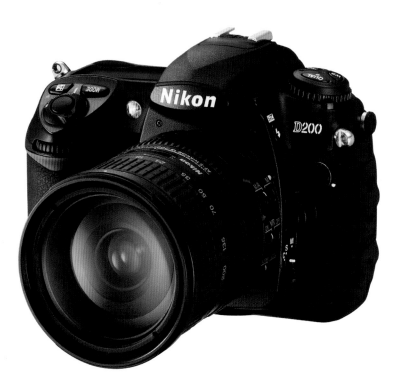

Digital SLR specifications

Excluding build quality, the single most important consideration when purchasing a digital camera is the resolution of the image sensor. When describing the 'size' of a digital image file, it's best to think in terms of dimensions, such as 3000x2000. There are several different sensors currently in use, each creating a file with different dimensions. Confusingly, digital image files are also described in megapixels (short for a million pixels), but this measurement is easily derived from its dimensions. A 3000x2000 image can also be described as a 6 megapixel image (3000 x 2000 = 6,000,000). Essentially, the more pixels the camera can make, the bigger and better print you can output.

Rear control panel

Digital SLRs plug into a wide range of lenses and accessories to fully enable the professional to shoot in different situations. Better cameras, such as the Nikon D200, have a large rear LCD viewer, so you can check exposure, focus and settings with ease.

Top LCD display

On the top LCD panel and mode dial are found controls for most shooting situations including aperture, shutter speeds, ISO, EV compensation and memory card capacity. On a well-designed camera body, essential switches and dials are placed ergonomically, within easy reach of your grip.

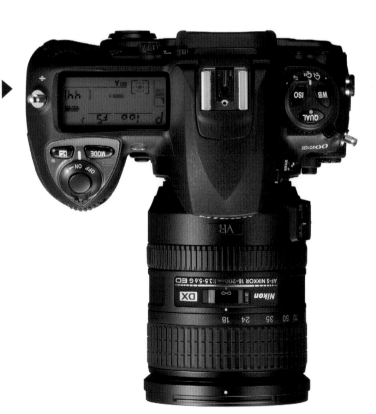

DATA STORAGE

Digital cameras produce a lot of data which needs to be stored quickly and efficiently, so you can carry on shooting. A large capacity storage card is essential for location photography, so you don't have to return home to download.

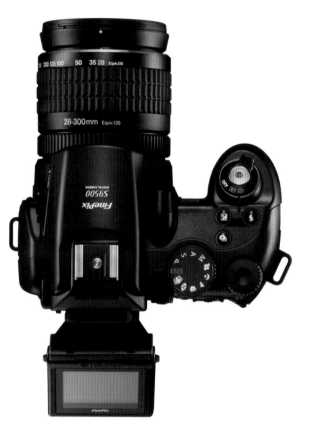

◀ File compression

Even an advanced compact type camera like this super versatile Fuji FinePix can create a large amount of data when set to shoot at highest resolution. Although image file data can be 'squeezed' into smaller-sized chunks for easier storage in a process called compression, the latest trend is to shoot and store in the RAW file format. Unlike JPEGs, RAW files are typically 20Mb and upwards in size and can soon fill up a storage card.

Image sensors ▶

The size and shape of image sensors, unlike 35mm film, are not yet universal. Major manufacturers, like Nikon, Canon and Fuji, employ a wide range of different sensor types, which capture images in different pixel dimensions.

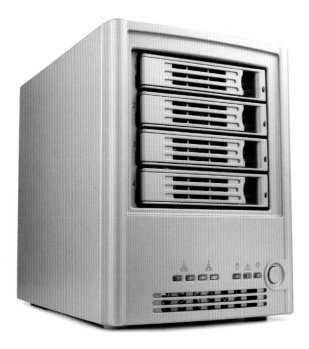

RAID array

Many professional photographers store and archive original files on a separate drive, rather than clog up the hard disk of a workstation. There are many different types of high capacity storage systems, but the most versatile option is a RAID array. Built on a modular system, a RAID array can grow in capacity as your needs dictate and can be accessed by many users across a network.

Storage cards

Like image sensor types, camera storage cards are not universal, but two of the most popular are the Secure Digital (SD) and the Compact Flash (CF) variants. Cards are sold with different storage capacities, such as 512Mb and 1Gb, with the larger capacity cards costing more. Like computer hard drives, cards are also sold on the basis of their access speed, or the rate at which they write data down. The faster the speed of the card, the quicker you can transfer data to and from it.

Firewire hard drive

A cheaper alternative to a RAID system is an external hard drive, such as this LaCie model. Most are small enough to be portable and better models can be powered solely through a Firewire connection.

CONNECTING TO A PC

The first step in any image editing project is the transfer of digital files to a computer. If you are considering updating your workstation, look out for the fast USB 2.0 or Firewire interfaces.

Transfer on location ▶

A professional laptop computer is a valuable tool for viewing your work on location and to store digital data transferred from your camera card. Good laptops are fitted with a wide range of ports and can accept external storage devices and cameras.

◀ ## Front ports

An Apple G5 tower computer has been designed with its ports on the front of the case, so you can easily plug in your digital camera, USB storage media or external hard drive.

▲

Pen drive

A USB pen drive is a low-cost way of transferring files between different computers.

Card readers ◄

Less ideal is to remove the card from your camera and insert it into a multi-format card reader connected to a computer. Camera storage cards are not designed for repeated handling and are vulnerable to physical damage to the gold-plated contacts.

Docking station ►

An innovative computer transfer system employed by some Kodak and Fuji compact cameras is the docking cradle. Left permanently plugged into your PC, the dock acts as a battery charger and data transfer link, so you don't have to fiddle about with wires and ports.

Port and plugs ►

The fastest kind of transfer is through a Firewire port, followed closely by USB 2.0. Most computers and cameras use the universal USB 2.0 connectivity, but the camera end of the data cable is rarely of a uniform design.

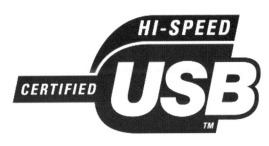

MANAGING YOUR FILES

There is no additional cost involved in shooting a hundred files rather than ten, but it will add significant time to your workflow. If you are about to embark on a project, it's a good idea to plan how you manage your data before starting.

Adobe Bridge

Bundled with Photoshop CS releases, Adobe Bridge is a separate application that is used to browse an extensive file collection. Although not part of Photoshop, Bridge triggers the image editing application when a file is double clicked and displays the metadata created by the camera, for your reference.

Adobe Photoshop Lightroom

Adobe Photoshop Lightroom is an integrated application that offers raw file processing and sophisticated file browsing. Once opened, Lightroom links to your folders of files and allows you to edit and tag your work with metadata, to facilitate easier retrieval. Lightroom creates large-size previews, so you can study and contemplate your editing decisions without squinting at a tiny thumbnail.

iView Media Pro

When digital files are created in the camera, they are named with a faceless numeral, making later identification almost impossible. It is important therefore to organize and edit your originals after transfer, using an application like Adobe Bridge, Lightroom or iView Media Pro. With the increasing data size of image files and the number of files contained in a shoot, it is impractical to access your files through the File>Open command.

Image settings

An innovative application, iView Media Pro enables you to store large volumes of files easily. Like most browser applications, iView can read and present the universal EXIF data alongside the image file, so you can refer to the original shooting settings stored at the point of capture.

Moving images

Operated in a simple drag and drop manner, iView can also create effective slide shows combining images, sound and video clips. ▶

DIRECT PRINTING

Great advances have been made in the design and quality of direct printing units, those peripherals that print directly from your camera or memory card without the need for a PC.

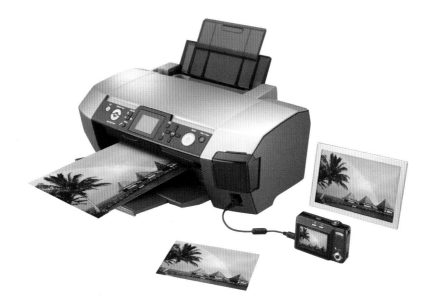

Direct printers explained

Models such as the Epson PictureMate have a six-colour inkjet cartridge using pigment inks rather than cheaper dyes, producing up to 4800dpi resolution; it is capable of producing stunning prints in just under two minutes. With micro-fine ink droplets, the smallest in its range by far, image quality is high and without the tell-tale specks of a typical inkjet print. The best way to produce prints for friends and the family album, your results cannot be distinguished from top quality conventional photo lab output and all at a fraction of the cost. As standard, direct printers link to your camera using the universal PictBridge or USB Direct Print protocols, but fewer models actually accept memory cards directly. All are fitted with a USB input terminal, so cameras and other devices can be connected without the need for a PC. The cost of ink consumables for this kind of device is high, so it would be as well to think about the oncosts before committing.

Borderless printers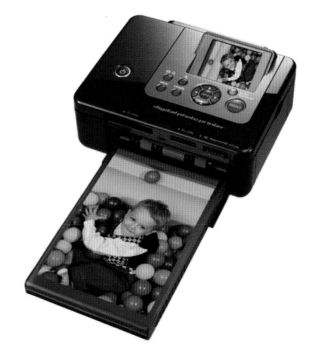

Most direct printers produce index-type prints with thumbnails so you can make a decision on which to print and many also offer the option of printing passport-sized images too. Borderless prints, the firm favourite for family albums are less universal, with many systems using paper with tabs or perforated-edge media. Prints are made with ultra-fast-drying ink, which means they are ready to hold once fully emerged from the printer. For top quality prints, most make good use of compatible cameras' Exif data, by interpreting the settings saved at the time of shooting.

Kiosk printers

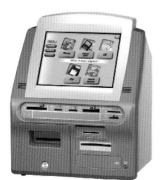

The printer then interprets camera settings such as white balance, sharpness and contrast and makes prints. The printer can also respond to a Digital Print Order Format, or DPOF, compatible camera, whereby files and print quantities on your camera can be determined before connecting up to your print device, such as this Fuji Kiosk.

Despite the attraction of setting your camera to shoot in enhanced contrast, sharpness or colour mode, direct printers can make all the adjustments for you between connection and print out, while you are left with a RAW unprocessed file for further trickery in your image editing application.

Exif data is a simple record of the camera settings used at the point of exposure. This is recorded automatically by the camera and attached invisibly to each image file. The data is used by direct printers to estimate the best printer settings to use.

Hints *and* Tips

INKS

Many inkjet inks are based on cheap dyes which are inherently unstable in daylight. Printed matter like magazines and newspapers are never designed to last very long and are produced with inks that fade easily. Choice of ink is as important to the digital photographer as good quality oil paint is to an artist.

Ink types and print quality

Better quality and greater longevity is achieved using pigment-based inks, rather than dye-based inks; oil paintings that are over 500 years old survive thanks to the type of colour pigment used to mix artists' oil paints. Desktop inkjet printers are calibrated to produce the best results using their own brand of ink and paper and will give disappointing results with budget materials. Printer software is painstakingly designed to call up highly precise amounts of colour and could fail to correct any unexpected colour cast caused by a budget product. Refillable cartridges and recycled ink sets are cheap because they are made with cheaper dyes that fade quickly, just like carpet and fabrics. Much better results can be obtained using products such as Epson's K3 Ultrachrome ink, which the manufacturer claims will last 80+ years before fading. Archival inks should be considered when you need to make prints with a guaranteed lifespan, such as a family photo album.

▲

Special inksets

Lysons Quad Black and Small Gamut inksets are innovative inks which fill standard four-pod colour cartridges with unusual ink. The Quad Black inkset substitutes the standard CMYK ink colours with four new colours with an identical tonal value such as black, dark grey, mid-grey and light grey. The benefit of using these products is the cast-free prints that have a greatly expanded tonal quality compared to those printed with CMYK. Lyson's Small Gamut inks are made using a swatch of blue or brown for reproducing traditional photographic printing effects. Currently only a limited number of printers can use Lyson inks, but the list is expanding each year.

Hints *and* Tips

A continuous ink system (CIS) allows the user to keep control over consummables costs by connecting large tanks of ink directly to the printer head through special micro-tubes sealed in a vacuum.

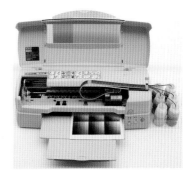

33

PRINTING PAPERS

The biggest revolution in digital printing may not be the convenience of printing from your desktop, nor even the endless possibilities afforded by digital manipulation software. Rather, it is the ability to print onto more exciting surfaces than gloss, lustre and matt.

How paper works

Print sharpness, colour saturation and contrast are all dictated by your printing media, even before you start enhancing an image in Photoshop or fiddling with the printer software. These restrictions are worth understanding before you start work, saving you effort, time and wasted consumables. Like glossy photographic paper, glossy inkjet papers and films produce the highest colour saturation. They have a shiny topcoat, enhancing the depth of black and shadow areas in a print; most light is reflected from this kind of media. Matt or coated surfaces, however, give a less intense result and certainly a weaker black. Under the microscope, a finely pitted china-clay coating reflects light in many different directions. Uncoated materials, such as art papers, have a fibrous surface that creates less saturation and a restricted tonal range.

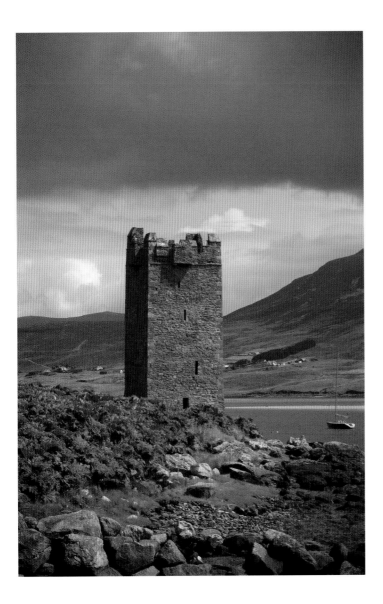

Exhibition quality paper

Special papers are available for producing high quality inkjet prints such as this baryta-based media from Harman Technology. Using the same paper base as conventional photographic paper, prints have the same look and feel as a silver-based image. A special warm-toned version is also available for reproducing toned images, such as the landscape shown left.

Paper quality

Regardless of the resolution of an image document and the halftone settings on your inkjet printer, some papers just can't cope with fine detail. Like cheap newsprint, poor quality papers do not have the surface coating to hold individual ink dots without spreading. Copier papers, writing papers and machine-made artists' papers all react like blotting paper: ink dots are merged into each other and sharpness will decline. In fact, these materials work much better if you use low-resolution images and low quality printer settings.

ESSENTIAL SOFTWARE

Professional image editing software is designed to help you manage every stage of the process from transfer to top quality output. The market is dominated by Adobe Photoshop and the latest arrival on the scene: Adobe Photoshop Lightroom.

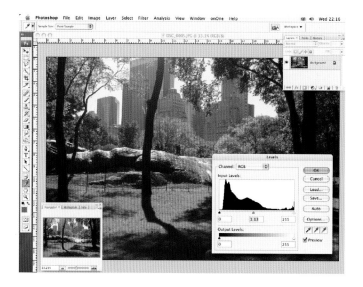

Adobe Photoshop

Adobe Photoshop is the leading brand of image editing software, used by all imaging professionals. The product is available for Windows PC and Apple Macintosh computers, providing a comprehensive assortment of tools for correcting and preparing images for print, web and multi-media output.

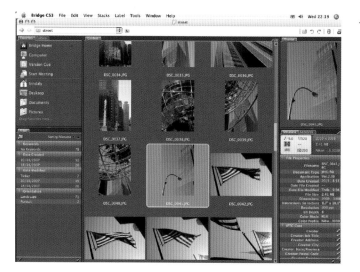

Adobe Bridge

Adobe Bridge is an essential application that works like an advanced file browser, enabling you to view and check your work before editing. Although not an image editor, Bridge presents essential shooting information alongside each shot, so you can see all the settings used. Once an image is clicked within Bridge, it opens in Photoshop.

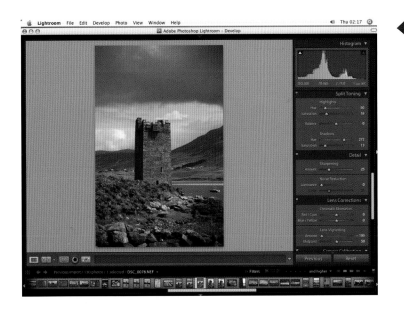

Adobe Photoshop Lightroom

Adobe Photoshop Lightroom is the latest application in the professional arena. Lightroom has been designed with a dual purpose: to act as both a cataloguing application and as a RAW file editor. Lightroom edits in a non-destructive manner, so your original images are never overwritten. At a third of the price of Photoshop, it is well worth considering.

Adobe DNG Converter

The Adobe DNG Converter is currently available as a free download and works by converting proprietary RAW files into a uniform format. Presently, all digital camera manufacturers use different variants of the RAW file format, which creates a compatibility issue with image editors. As each new camera arrives on the market, so another version of the RAW file emerges. The DNG Converter solves this by making each file readable.

SOFTWARE PLUG-INS

Plug-ins are useful additions to an image editing application and can be installed with a minimum of technical fuss. Made and distributed by third-party companies such as OnOne, they are designed to work within Photoshop, Photoshop Elements and other major applications.

Plug-ins explained

Plug-ins extend the usefulness of an editing application by adding new functions or filters. Creative filters, wacky edges, colour effects and lighting effects form many of the plug-in packages, but there are also functional ones for dealing with tricky technical tasks such as cutting out. Genuine Fractals is an innovative plug-in that creates better quality image enlargements. Once installed, plug-ins appear as an extra item in the dropdown menus, so you can access them easily. Like Photoshop's Extract command, most plug-ins are operated via a comprehensive dialogue box where you can see the likely effects of your handiwork before committing to the edit.

Most plug-ins can be bought over the internet, either in mail order form or as a downloadable file. Best of all, most plug-in manufacturers offer trial versions of their software through a free download so you can try them out first. Trials are essentially limited versions of the full package and offer either reduced controls or produce the final image with an indelible watermark. There are many plug-ins for Photoshop and even more specialist plug-in portals on the web, where you can find quick links to websites without wasting time surfing. Like many other software applications, free doesn't necessarily mean good.

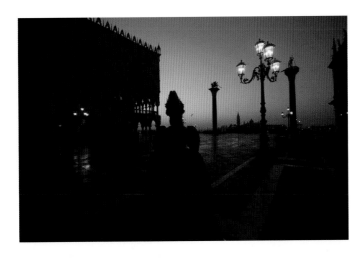

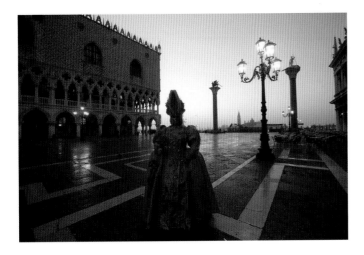

PhotoMatrix Pro

PhotoMatrix Pro is a High Dynamic Range (HDR) image processor which works as a standalone application or as a Photoshop plug-in. It works by combining three separate images, each created with a different exposure, into one single image displaying a wider tonal range than would normally be possible in a single attempt. The application has received excellent reviews and it offers photographers the opportunity to extract usable results from poorly lit scenes on location. Three different exposures need to be taken from the outset, using a tripod to ensure alignment later on. PhotoMatrix Pro also allows you to create a tone-mapped image from an existing image file, so you can retrospectively rescue detail from an image file that you thought had not recorded.

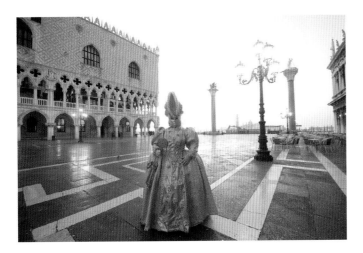

Three different exposures, shown left, were taken during a tricky evening scene which would not record detail in both shadows and highlights simultaneously. These can then be blended together. See pages 58-59 for more on HDR.

CALIBRATION HARDWARE

You can't just switch a monitor on and hope for the best – it needs careful calibrating for a guaranteed cast-free colour display. Even though the contrast and brightness of most monitors can be manually adjusted using dials and buttons, it is better to use hardware tools to make adjustments.

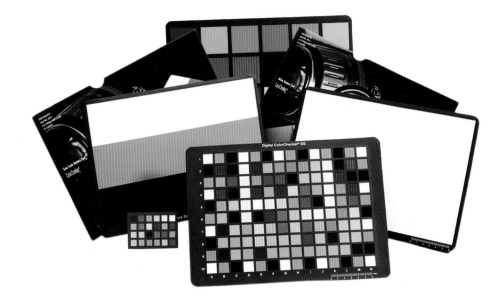

Measuring kit

Colour calibration is a constantly evolving subject, as professional photographers and their clients become more discerning. With each advance in colour reproduction comes associated hardware-measuring devices to ensure as many variables as possible are eliminated from the process. A good starting point to colour calibration is the purchase of colour checker charts, as shown above. These are available for use with a digital camera, artwork scanner and film scanner and offer a fixed colour reference point that can be measured by a hardware device later on. Armed with a reliable hardware kit, such as the X-Rite brand, photographers can control and manage all aspects of colour reproduction throughout their workflow, including monitor, print and even digital camera calibration.

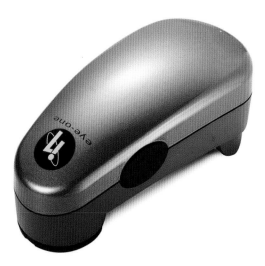

Dual profiler

The Eye-One kit from X-Rite offers a very high specification device, shown left, called a spectrophotometer. Unlike lesser devices, the Eye-One can accurately measure light reflected by prints, light transmitted by monitors and even the ambient light in your working environment. The device can be used to profile your monitor, create bespoke printing paper profiles and even calibrate a data projector to perform better. See page 78.

Paper profiler

The Eye-One spectrophotometer can be used to create paper profiles, as shown here. A reference file is first printed off using the desired paper, ink and printer combination, then the printed ink colours are measured to create a bespoke profile. This tiny file can then be used to control both soft-proofing and better print quality.

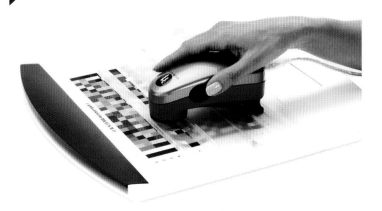

Monitor profiler

At around a tenth of the cost of a professional hardware calibration set is a simple monitor calibrator. This device works by plugging into CRT (cathode ray tube) and flat-panel monitors and laptops to create an accurate profile through its own, easy-to-follow software routine. Once the file is saved and stored, it is targeted each time the device is switched on.

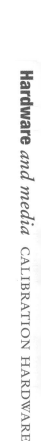

2

Preparing for *print-out*

SETTING UP YOUR MONITOR

When digital images are exchanged between different input,
editing programs and output devices, some shift in colour will occur.
Keeping control of these changes is called colour management.

1 Starting point

Position the monitor in the best place before you undergo calibration. Reflections off the screen will always cause havoc with colour accuracy and will make image colours look bland or washed out. If you've got control over your environment too, then don't sit next to walls painted a vivid colour or wear wild-coloured clothes yourself, as these will both reflect badly on the monitor. A monitor shade is a very useful addition to your kit, as this prevents unwanted glare and reflections compromising your work.

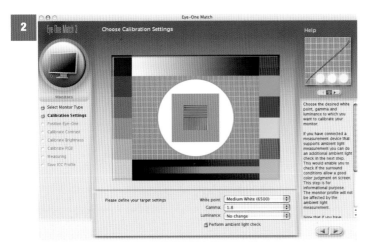

2 Identify the source

Software-only calibrators such as Adobe Gamma produce adequate results but are not as accurate. Once the monitor calibrator is attached to the screen, you will need to identify the source to be measured.

3 Correct the variables

Calibration centres on setting a common brightness, contrast and colour balance for a device. Use the hardware buttons on the monitor to correct any imbalances.

4 Name and save

Once your own individual corrections have been made, you can save and store them for permanent reference. Always add a date in the filename and repeat this process each month.

CROPPING

You can improve camera composition in Photoshop by using a range of cropping tools. Use the crop tool to recompose an image by shaving off excess pixels from the image edges.

1 Starting point

This image is an example of awkward composition, with too much empty space in the foreground. The purpose of recomposing an image file is to draw attention to the main subject and create emphasis where it should be.

When using the Crop tool in Photoshop, you are effectively removing pixels from the chessboard-like grid of the image file, so the maximum print size will decrease each time you slice a row or column off.

2 Defining the crop

Click into the top left-hand corner of the image and then drag the Crop tool to the bottom right. Try and exclude as much of the unwanted space as possible. Photoshop darkens down the unwanted areas, so you can preview the likely effect of the edit before committing to it. Once you have decided on a new composition, press return on the keyboard.

3 Finish

Although only a minor edit, the final version is much stronger, creating a symmetrical composition. This kind of effect is created when two halves of an image balance out in perfect harmony. Imagine folding the photograph in half and if both sides look the same, then you have created a symmetrical effect.

Hints *and* Tips

Hidden under the Image menu is found the Trim tool. This removes any thin lines of white or black pixels surrounding your image after cropping or scanning and is much easier than the Crop tool to use for removing small slivers of pixels around the perimeter edges.

CORRECTING CONTRAST

Many digital images need to have proper contrast established before printing, or else the results will be flat and disappointing. Photoshop offers several different tools for correcting contrast, each creating a slightly different result.

Contrast fundamentals

Largely caused by the results of file compression in the camera, the initial contrast of an image is often low and visually very disappointing. To save data, extreme white and blacks are excluded, leaving a muddy and insipid result.

This example, left, shows an image before and after contrast correction using the Levels tool. Notice how significantly the colour balance is affected by this edit. Contrast is the first and most important edit in the sequence.

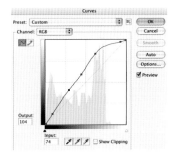

Brightness/Contrast

The easiest tool to use, but the one which causes most damage to your file. As each slider is moved, the same rate of change is applied to each pixel in your image, regardless of its current brightness. This creates white and black holes in your files, with no visible detail, which creates very poor prints. Notice how much lighter-shaded detail has been lost in the sky and how much darker the bumper is now.

Levels

A simple and effective way to restore white, black and midtone values is with Levels. The Levels dialogue allows you to remap tone using three simple triangular sliders which you can slide right to left. Unlike the Brightness/Contrast dialogue, Levels edits can be made to highlight, shadow or midtone areas independently.

Curves

The most difficult to master, but the most sophisticated tool in the box for correcting contrast is Curves. Unlike Levels, the Curves control allows you to independently edit up to 15 separate tonal areas in an image, so you can precisely adjust the brightness of individual colours, selection areas and tonal sectors. Easily the professional's favourite.

49

FIXING COLOUR BALANCE

Faithful colour reproduction is a never-ending pursuit for professional photographers and printers, a process made much more complex by the introduction of an enormous variety of cameras, scanners and printers working with completely different standards.

Where to spot colour casts

The best place to see colour casts is in a neutral area, preferably grey. White highlights and shadows will never show a cast in its true colours, nor will a patch of strong colour, but if you are lucky to have a midtone grey in the image, you'll get a much better idea about the extent of the problem.

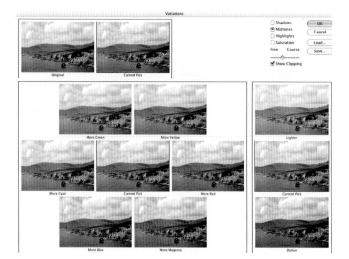

Using variations

Displayed in six different variations with the original at the centre, casts are removed by simply clicking on the best-looking option. Control over delicate shifts in colour can be made by sliding the scale from Coarse towards Fine.

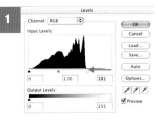

1 Use Levels

Start by dragging the highlight slider, as shown left, into the centre of the graph, so it sits at the bottom of the mountain-like shape known as the histogram. This has the effect of brightening the image. Repeat to the shadows if necessary.

2 Use Color Balance sliders

With a straightforward daylight shot such as this, all you need to do is to warm the image up slightly. Click the Midtone check box and then move the yellow slider until the image starts to look richer in colour.

3 The end result

Compared to the bland starting point, the final print looks closer to the original scene.

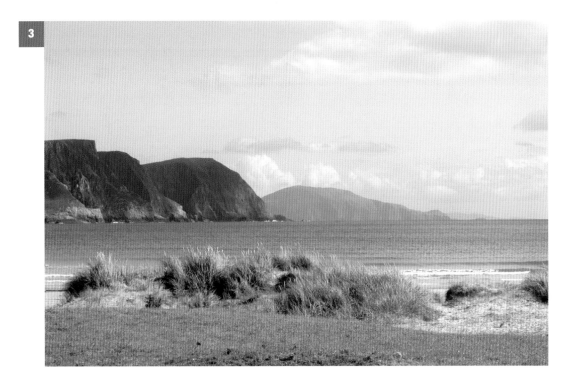

FIXING COLOUR SATURATION

With digital camera images there will always be some disappointment when the file is viewed in its raw state for the first time. Digital data for high resolution images is considerable and, as a consequence, is designed to be lean and faster to manage.

1 Hue/Saturation method

A greater range of colour means more data, so unprocessed compressed files are always desaturated and bland. Rich colours can easily be put back or made even more vivid than they were in the original scene.

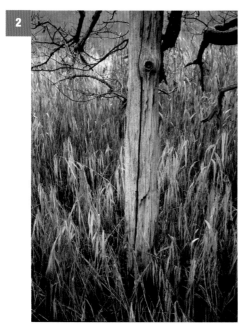

2 Colour corrected

Every image benefits from a slight increase in saturation values, by using the Hue/Saturation dialogue. An extra 10–25 units will be enough. Use the Master channel in the dropdown menu to change the entire image, or target individual colours with your edit.

1 Sponge tool method

Click on the Sponge tool and choose the Saturate option from the dropdown menu on the contextual menu. Set the flow to around 50%, then choose a large soft-edged brush, like a 50 pixel size. Apply the tool to areas of the image that you want to boost.

2 Saturate colour areas

As you paint with the Sponge tool, you will slowly 'remove' the weaker colour and replace it with a much more vivid value. If your chosen area is a tricky shape to paint into, isolate the area first with a selection, then watch as this creates a kind of fence around your edit.

3 Final result

It is better to set the Sponge tool to a low value and repeatedly apply the tool, rather than perform the edit in a single hit. Aim for subtlety rather than maximum volume.

UNWANTED BACKGROUNDS

If your photographs are ruined by the appearance of unwanted items, you can paint them out with the Clone Stamp tool. It works by sampling or copying a section of the image and pasting it over another area, but in real time.

1 Starting point

The real skill of the tool lies not in its application but in the selection of the starting sample area. Like all other painting and drawing tools in the box, the Clone Stamp tool can be modified by brush size, shape and opacity and also by its blending mode. Unlike any other painting tool in the Photoshop toolbox, the Clone Stamp tool has no connection with any real-world painting technique and will feel like painting with a brush loaded with 'image' rather than colour.

2 Selecting the area to clone

With your non-mouse hand placed over the Alt key, move the clone tool onto an area of the image you want to sample. Next, press and hold the Alt key and click once. Notice the tool icon changing as you make the sample. Move the tool cursor away from the sample point and position it over the area you want to remove. As you start painting, a tiny crosshair will appear to tell you which part of the image you are sampling from.

3 Painting in

The tools' Aligned mode is used to retouch in a different part of the image but it fixes the distance from sample area to painting area. This means you need to have two sets of eyes to watch what you're copying and where you're pasting it. If the sample point isn't changed regularly, a repeat 'herringbone' pattern will appear.

4 Finished result

The end result looks convincing because the foliage area is unfocused and not sharp. To make your retouching more accurate and stop it from spilling over into unwanted areas of the image, make a selection first to limit its effects. This restricts the painting area to exactly the part you want to alter and is ideal for geometric shapes and other hard edges.

DUST AND SCRATCHES

You can easily remove visible dust and scratches from images using a simple filter routine in Photoshop. Software filters work in exactly the same way as conventional camera filters but have the additional advantage of variable intensity. If used carefully, the filters can also be used in 'reverse gear'.

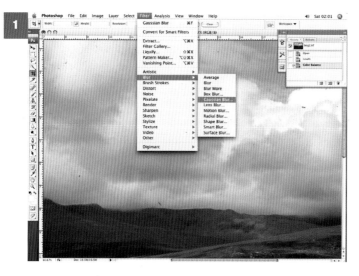

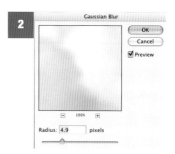

2 Set the Blur

In the Gaussian Blur dialogue move the slider until the hairs and scratches blend in with the sky.

1 Starting point

This image was scanned from a dusty old transparency. Start by doing a Filter>Blur>Gaussian Blur command.

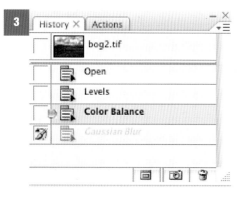

3 Set the History state

Select the History Brush tool, then open the History palette. Reverse out of the previous command by selecting the previous state, shown here coloured blue. The image will now become sharp again. Next, click the History Brush tool in the tiny square next to the Gaussian Blur state.

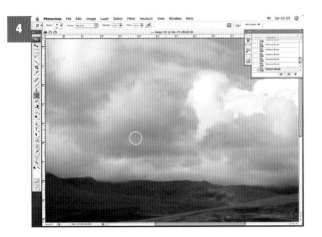

4 Paint away the dust

By reversing back one command and then selecting the now defunct Gaussian state with the History Brush, you are effectively painting back the blurred state with the brush. Watch how each speck of dust disappears against its surroundings. This technique is far easier than cloning and much faster too.

5 The end result

Unlike a heavily clone-stamped image, this example suffers less visible damage as a result of editing. The History Brush is ideal for blending together unfocused elements, such as a sky, but is less successful in sharply detailed areas of an image.

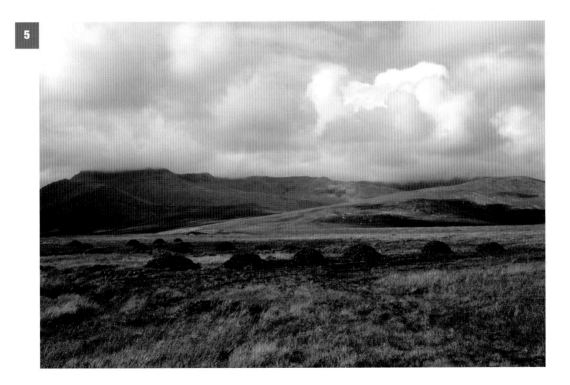

HIGH DYNAMIC RANGE

High dynamic range processing is a method of extracting the perfect tones from several bracketed exposures of a single subject. If you have not heard of the latest technique to hit digital photography, then now is the time to experiment with high dynamic range, or HDR, as it has become known.

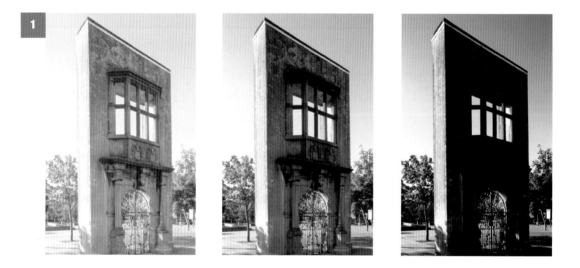

1 Create three source exposures

HDR processing offers a hands-on technique for mixing the perfect tonal blend across shadows, highlights and midtone areas and all without the use of selections, masks or layers tools. In fact, there's even no need to use levels or curves to organize the image ready for printing. Very rarely does perfect lighting exist on location and on those occasions when your camera exposure captures the details in a bright sky, but not in the darker landscape, HDR processing can be used to improve the image. PhotoMatrix Pro works by mixing and merging together individual files which have been exposed under different conditions in a shooting technique called bracketing. Instead of trying to capture all within one single image, three or more different files are created at the scene, each exposed differently to get the best out of highlight, midtone and shadow areas.

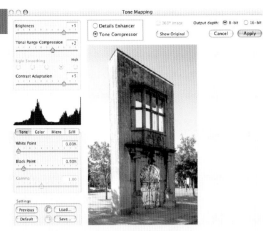

2 Blend together

Once opened, PhotoMatrix Pro asks you to select your subject files, then provides the HDR>Generate dialogue asking for instructions. Once the images have been combined the initial result may look dark. This is because the HDR can't be fully represented without additional processing. At this stage, you can save the initial version and treat it in much the same way as a RAW file, available for processing and re-interpretation later on.

3 Refine and finish

The third stage is the truly creative one: choose the Tone Mapping option from the HDR menu. Once the dialogue appears, you are faced with a choice of three different resolution previews, so choose the largest that the monitor can accommodate. The dialogue offers two ways of interpreting the HDR file – either using the details enhancer method or with the tone compressor. These two options offer slightly different tools for adjusting the file, but the details enhancer will produce the most dramatic results.

CONVERTING TO MONO

Although many digital cameras offer the ability to capture a scene in greyscale, it's much better to shoot in RGB colour mode, then make the conversion in Photoshop. Here, you can change the intensity of each individual colour before you change it into a shade of grey.

1 Starting point

This example is an insipid file, shot in difficult lighting. Without any processing, this would make a very poor print. The aim of the project is to intensify the blue sky to create more contrast before converting to a warm-tone monochrome.

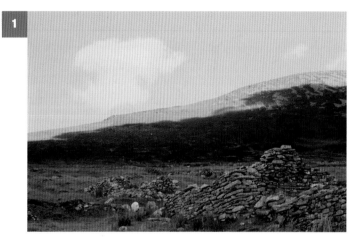

2 Black and White

Photoshop offers several alternative ways to change a colour image into monochrome: by simple mode change; or by Image>Adjustments>Desaturate. The best method is to do an Image>Adjustments>Black and White command.

3 Choose a Preset

Click into the Preset pop-up menu at the top of the Black and White dialogue box. Choose the High Contrast Red filter option and watch how the image changes. The Blue value is dropped to –50, making the sky appear much darker.

4 Warm up with a Photo Filter

The final stage is to add a slight colour tint to the mono image before printing. Do Image>Adjustments>Photo Filter and choose the Warming Filter (85) with a density of 25%.

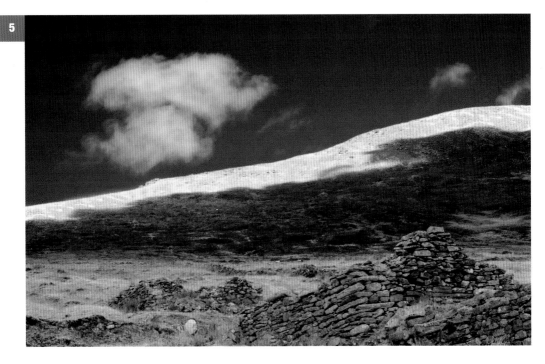

5 The finished print

Compared to the bland starting point, the final print looks much more atmospheric.

SPLIT-TONING

A split-toned image rises above the all-encompassing wash of a single tone.
Using two, three or even four different colours, you can drop each one into a
precise tonal sector of the image and, best of all, keep meddling until it's right.

1 Starting point

Photoshop provides many tools for creating toned images, but the Hue/Saturation slider is hard to beat. The image needs to be desaturated first and still in the RGB image mode for this edit to work.

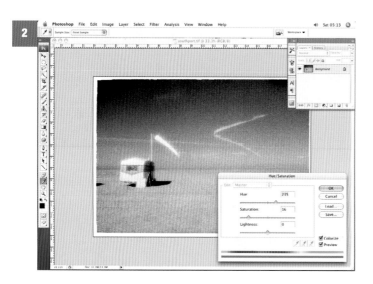

2 Add colour

Click on the tiny Colorize button on the bottom right of the dialogue and watch the image take on a vivid colour. Decrease the Saturation slider to look more subtle and move the Hue slider until you find the right colour.

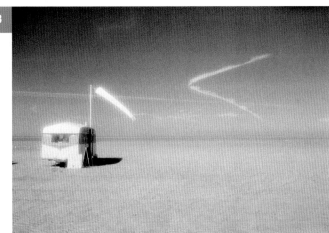

3 Finishing line

Only a slight blue colour change was introduced to this image, just enough to keep the monochrome feel.

Using Lightroom

Lightroom offers a versatile split-toning tool, hidden under the Develop menu. Here you can add two different colours into an image and determine the saturation value of each one too.

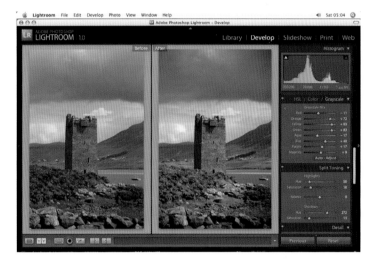

Select a bright colour such as yellow for the highlights and a richer darker colour like purple for the shadow areas. Experiment with the saturation levels until you can see the two mix together onscreen, without looking overcooked.

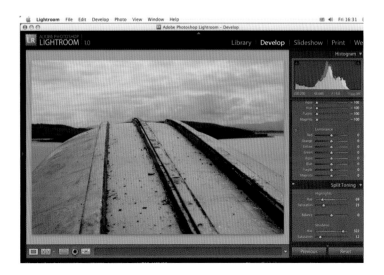

63

CHECKING COLOUR GAMUT

Despite the ability to display in excess of 16.7 million colours, a monitor will show certain colours that can never be reproduced on an inkjet printer. The way to preview this outcome is to use Photoshop's Gamut Warning controls.

1 Starting point

This example image is partly constructed from saturated pinks and reds which display vividly on screen. Yet, these are unlikely to print with the same intensity because they are beyond the range, or gamut, of the printer.

2 Select Gamut

From Photoshop's View menu, select Gamut Warning. This control can be toggled on and off by using the Shift+Command/ Ctrl shortcut, as you work through a project, or simply left on all the time.

3 Grey markers

Once switched on, the Gamut Warning tags all non-printing colours a grey tone. The grey is only a marker and will neither print nor remain embedded in the file. Notice how the highly saturated colours are most affected.

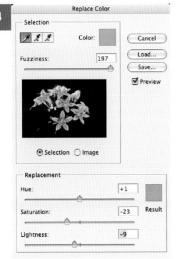

4 Replace colour

To change the problem colours into values that will print, choose the Replace Color dialogue. Use the dropper tool and click it onto the saturated value in the image. Next, move the Fuzziness slider until the tiny preview image shows all the colours that you want to alter. Finally, experiment by moving both Saturation and Hue sliders, until the grey marker colours disappear from the image.

5 Ready to print

Return to the image window and see how the image appears. By lowering the saturation values, the image displayed onscreen will now be closer to the printed end result.

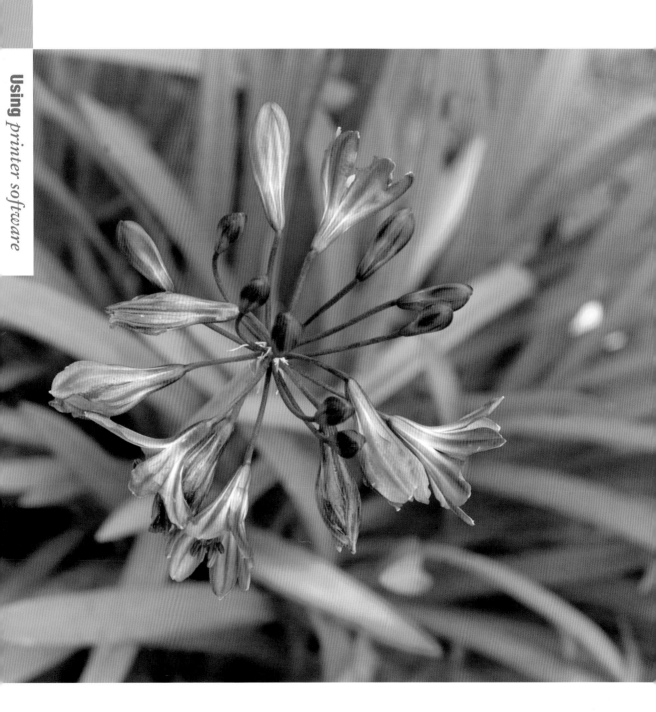

3

Using *printer* *software*

DEFINING COLOUR SETTINGS

Once you've set up your monitor properly, you should spend a little extra time deciding how Photoshop's colour management tools will work for you. Like all professional applications, Photoshop can be customized to work under special colour conditions.

1 Colour settings

Photoshop can be set to work with Adobe RGB (1998) as its default workspace by doing Edit>Color Settings. When the dialogue appears, click on the More Options button. Next, move your cursor into the Working Spaces panel and click hold on the RGB pop-up and select Adobe RGB (1998) from the list, as shown.

2 Set up the workspace

Some workspaces are less used and have a smaller colour palette than others, such as the sRGB space, so the best option is to use the most universally-recognized workspace such as the Adobe RGB (1998). This workspace is the best for most accurate colour printing and will not cause colours to change.

Color Settings

Unsynchronized: Your Creative Suite applications are not synchronized for consistent color.

Settings: July_07

Working Spaces
RGB: Adobe RGB (1998)
CMYK: U.S. Web Coated (SWOP) v2
Gray: Gray Gamma 1.8
Spot: Dot Gain 20%

Color Management Policies
RGB: Convert to Working RGB
CMYK: Convert to Working CMYK
Gray: Convert to Working Gray
Profile Mismatches: ☑ Ask When Opening ☑ Ask When Pasting
Missing Profiles: ☑ Ask When Opening

Conversion Options
Engine: Adobe (ACE)
Intent: Relative Colorimetric
☑ Use Black Point Compensation
☑ Use Dither (8-bit/channel images)

Advanced Controls
☐ Desaturate Monitor Colors By: 20 %
☐ Blend RGB Colors Using Gamma: 1.00

Description
July_07: July_07

Save As

Save As: flower

timdaly

Network
Macintosh HD
Library
LACIE
Desktop
timdaly
Applications
Documents
Movies
Music
Pictures

Desktop
Documents
Library
Movies
Music
Pictures
Public
Send Registration
Sites

Format: TIFF

Use Adobe Dialog Save: ☐ As a Copy ☐ Annotations
☐ Alpha Channels ☐ Spot Colors
☐ Layers
Color: ☐ Use Proof Setup: Working CMYK
☑ Embed Color Profile: Adobe RGB (1998)

New Folder Cancel Save

3 Colour policies

To prevent a colour conversion disaster, the process can be managed by a tiny piece of software called the Color Management Module or Engine. The Adobe (ACE) colour management tool is provided free with Photoshop. When opening images that have been captured in another workspace, you can configure your CME to deal with the problem in a number of different ways. Most common is to convert images from a smaller space into your current but larger workspace. The second option is to preserve the integrity of the image's workspace, useful if you are only viewing rather than editing.

4 Tagging your files

The final stage of managing colour in your workflow is to save your files with a colour profile. Known as tagging, this process will preserve the unique colour palette that your image was created in. When your image is ready to save, ensure that the Embed Color Profile box is ticked, as shown left. This profile will be the same RGB variant that you set up in Step 1. Most digital cameras now capture images with an embedded profile, but this ensures that your policies are enforced.

PRINT SETTINGS EXPLAINED

You can influence the final quality of the image as much in the printer software as in Photoshop. To keep on top of the numerous variables, it is essential to know what each setting means and how it can influence a print.

1

Print
Printer: Stylus Pro 4800-1
Presets: Standard
Print Settings
Page Setup: Sheet
Paper Tray
Media Type: ✓ Photo Quality Ink Jet Paper
Color: Singleweight Matte Paper
Mode: Enhanced Matte Paper
Archival Matte Paper
Watercolor Paper – Radiant White
Textured Fine Art Paper
Velvet Fine Art Paper
UltraSmooth Fine Art Paper
Plain Paper
Plain Paper (line drawing)
Singleweight Matte Paper (line drawing)
Tracing Paper

(?) (PDF ▾) (Preview) (Cancel) (Print)

1 Print settings

After selecting the printer, paper size and feeding mechanism, the most important control is the Media Type pop-up menu. Here, each type of media option is described and, after you have made your choice, the printer software automatically triggers the optimum settings for you.

2 PDF preview option

A much under-used feature of the Print dialogue is the PDF Preview. This option creates a separate PDF document, so you can double-check the layout, proof print, or even email your client for approval.

3 Color management

In the Printer Color Management dialogue are several controls which will change a print significantly. If you are printing with a paper profile, the Off (No Color Adjustment) option must be selected, otherwise there will be two competing management systems working simultaneously. If any non-profiled media prints with a colour cast, use the colour sliders in this dialogue to correct it.

The screenshot (panel 3) shows the following Print dialogue settings:

- Printer: Stylus Pro 4800-1
- Presets: Standard
- Printer Color Management
 - ⦿ Color Controls
 - ○ ColorSync
 - ○ Off (No Color Adjustment)
 - Mode: EPSON Standard (sRGB)
 - Gamma: 1.8
 - ▼ Advanced Settings:
 - Brightness: 0
 - Contrast: 0
 - Saturation: 0
 - Cyan ○ : 0
 - Magenta ⦿ : 0
 - Yellow ○ : 0
 - Buttons: (?) (PDF ▾) (Preview) (Cancel) (Print)

4 Paper controls

For advanced users only, the Paper Configuration dialogue offers a useful control for adjusting colour density, useful when printing onto non-standard media such as porous artists' paper.

The screenshot (panel 4) shows the following Print dialogue settings:

- Printer: Stylus Pro 4800-1
- Presets: Standard
- Paper Configuration
 - Color Density: 0 (%) (−50 to +50)
 - Drying Time per Print Head Pass: 0 (0.1sec) (0 to +50)
 - Paper Feed Adjustment: 0 (0.01%) (−70 to +70)
 - Paper Thickness: 1 (0.1mm)
 - Paper Suction: Standard (Default)
 - Cut Method: Standard
 - Platen Gap: Auto
 - Eject Roller Type: Auto
 - Buttons: (?) (PDF ▾) (Preview) (Cancel) (Print)

TESTING PAPER

Shadow gain and highlight spread is a common problem when printing photographs on inkjet printers, but if you're prepared to spend a little time calibrating the paper then you'll get rid of the problem for ever.

Using Canon print software

Different papers will respond to different printer software settings, but many images still need extra corrections for flawless prints. The idea of testing paper beforehand is a straightforward one and very cost effective in the long run.

Simple testing involves finding the exact points at which the paper can't separate dark grey from full black and pure white from light grey. Once this has been established and accounted for, your prints will no longer burn out in the highlights or fill in shadows. This sample print, left, was produced directly from Canon's Pixma printer software.

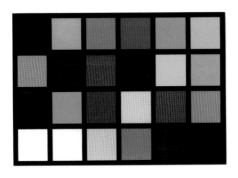

1%
2%
4%
6%
8%
10%
20%
30%
40%
50%
60%
70%
80%
90%
92%
94%
96%
98%
100%

Testing paper

This sample image file, left, was constructed using a scanned colour test chart and a simple scale showing each ink colour at a given percentage. To test the media, select a sheet of your favourite printing paper and send a similar image file to print using the closest media settings options found in the printer software.

It is important to make a note of these settings on the reverse side of the paper when it emerges from the printer. Inspect the print-out closely in the shadow areas on the black percentage scale and spot when the different steps merge together. On all but the very best inkjet paper this occurs at about the 94% mark, changing any darker tones into 100% black. Next, judge the highlights and pick the step before the first sign of any image detail.

Printer profile charts

Supplied with all good quality profiling equipment, these are printed out and scanned to create a bespoke paper profile, so you can achieve consistent print quality.

MAKING TEST PRINTS

You'll never achieve a perfect print on the first attempt. Conserve your expensive print consumables by making smaller test prints before committing to a full-size output.

1 Judging a print

The first task when making a test strip is to identify a small area of the image that contains the full range of highlight and shadows. Like an experienced darkroom photographer, it is essential that you use the same media and printer software settings throughout.

Always ensure that the paper stocks remain the same throughout the process. The advantage of printing out a smaller selection area is that you can opt to use much smaller sheets of paper instead of wasting an entire sheet on a small test area.

2 Make the selection area

With the Marquee tool drag a rectangular selection around the area you want to test. Ensure that the selection is hard-edged as a feathered edged selection will not print.

3 Print dialogue

To ensure that the selection is printed, check the Print Selected Area box in the Print dialogue. Load paper that is larger than the size of your selection, then press Print. The selection will always be printed in the centre of the media.

4 Test results

The first test, shown left top, was far too dark. The image was then modified and made lighter for the second test, shown left bottom. This was now too light. The Levels command was cancelled in the History palette and then adjusted again to make the third and final test strip, shown left middle. This finally captured an agreeable balance between shadows and highlight values.

SAVING PRINTER SETTINGS

If you don't have a hardware printer profiling kit, all is not lost.
You can easily save and store the settings used for your most successful
test prints and create your own unique reference file.

1 Prepare to print

To start the process, test the printer settings against your chosen paper and ink set until you have reached a satisfactory level of quality. Note down the settings as you work, then press Print.

2 Choose the printer and paper

Choose the target printer and paper size and make sure that the orientation is in the correct position.

3 Choose the settings

Based on the test prints, now reset the chosen settings, including Media Type, Mode and Print Quality. The purpose of saving the settings is so you don't have to remember these variables each time.

4 Set Printer Color Management controls

Return to the dropdown menu and choose Printer Color Management. For this collection of settings it is likely that you have controlled any print colour cast, caused by the reaction between ink and media, by using the Cyan, Magenta or Yellow sliders. This example has a slight Magenta correction.

5 Presets menu

Next, click into the Presets dropdown menu and choose the Save As option. This is the menu where the saved printer settings will be stored and retrieved each time. Notice a previously saved setting that I have called Somerset.

6 Name the setting

When prompted by the Save Preset dialogue, type in the name of the setting. If you are using more than one kind of ink, enter the name of this together with the paper and surface type. Press OK.

7 Retrieve the setting

After step six, you can return at any time and retrieve the complex group of settings by simply clicking the Presets dropdown menu.

77

USING PAPER PROFILES

In digital photography there is no such thing as a closed colour loop. In fact with so many different devices for capture, display and output from different manufacturers, colour consistency is rare. When images are transferred between different hardware devices, software applications and printers, colour change is inevitable and will strip an image of its delicate and subtle hues.

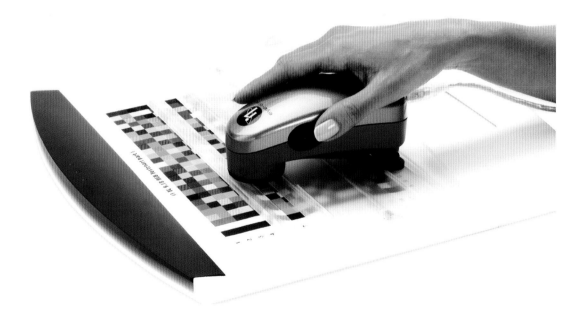

The Spectrophotometer

The X-Rite Eye-One device is a precision tool for measuring reflective and transmitted colour. This multi-purpose unit can be used to calibrate monitors, to produce unique print profiles and also to measure the amount and colour of ambient light in a working environment. The Eye-One is a popular, single-unit solution for photographers, graphic designers and print industry professionals. Used with profile-generating software, it enables you to get the best out of the ink, paper and printer at all times.

1 Target the profile

Firstly, in the Print dialogue box, make the profile visible and alter the intent as shown in the Print Space pop-up menu. This ensures that Photoshop targets the media when preparing for print.

Print

Position
Top: [] cm
Left: [] cm
☑ Center Image

Print...
Cancel
Done
Page Setup...

Scaled Print Size
Scale: 100% ☐ Scale to Fit Media
Height: 20.003 cm
Width: 13.229 cm
☑ Show Bounding Box
☐ Print Selected Area

☑ Show More Options

Color Management

Source Space:
Document: ⦿ Document: Adobe RGB (1998)
Proof: ◯ Proof Setup: U.S. Web Coated (SWOP) v2

Print Space:
Profile: [HARMANMattFBMpEpson2100photoK_0107]
Intent: [Perceptual]
☑ Use Black Point Compensation

2 Media settings

Next, adjust the settings in the Printer Software dialogue box to reflect the recommended media settings. For this example, the manufacturer recommended that my Epson 2100 printer software be set to Watercolour Paper – Radiant White media option.

Print

Printer: [Stylus Photo 2100]
Presets: [Standard]

[Print Settings]

Page Setup: Standard
Media Type: [Watercolor Paper – Radiant W...]
Ink: [Color]
Mode: ◯ Automatic
 ◯ Custom
 ⦿ Advanced Settings
 Print Quality: [Photo – 1440dpi]
 ☑ MicroWeave
 ☐ High Speed
 ☐ Flip Horizontal
 ☑ Finest Detail

Help

3 Turn off printer controls

The final setting is made to the printer software's colour management controls, which are all turned off. Click the No Color Adjustment button. Once set, you can start printing.

Print

Printer: [Stylus Photo 2100]
Presets: [Standard]

[Color Management]

◯ Color Controls
◯ ColorSync
⦿ No Color Adjustment

Help

(?) (PDF ▼) (Preview) (Cancel) (Print)

SOFT-PROOFING

Photoshop features an effective tool for predicting how a print will look onscreen on different paper stocks. In the complex and costly world of commercial printing, taking risks can be an expensive mistake. Yet if you could predict exactly how your work in progress will print out, you could save yourself a lot of time and aggravation.

Photoshop builds up a library of new profiles each time you install new printer or scanning software. These profiles can be called into play when you want to use a particular type of print paper and, most importantly, predict the likely outcome. Just like the Gamut Warning predicts non-printing colours, Photoshop's Soft Proof function mimics the likely look of the printed version on the monitor. Many saturated colours, especially deep blues and purples, cannot be reproduced with the same intensity by matt or cotton papers, so the Soft Proof function is a vital tool for seeing exactly how it is going to print out.

1 Setting up

Prepare the image for printing as normal, then do a View>Proof Setup>Custom command. This will bring up the dialogue box, where you can select the exact profile for the paper.

2 Select the profile

In the Device to Simulate dropdown, hold and click on the colour profile for the target paper. Next select Relative Colormetric, Black Point Compensation and Simulate Paper White to mimic the way colour appears on the paper.

3 Preview switched off

Without the Preview function, the image appears in full saturation, but this does not show how the image will look after printing.

4 Preview switched on

When Preview is switched on, the blues in the image are slightly muted. Notice the profile name appears at the top of the image window.

CUSTOM PRINT SIZES

You don't need to print all your digital photos on A4 paper – you can create custom paper sizes for the desktop printer. If you delve deep enough into the printer software settings, you'll finally reach the most interesting commands – those that allow you to break free from the preset paper sizes.

Even if you've got a basic A4-sized printer, you can still make much bigger prints because you are only restricted by the width of the printer, not the length of paper. Taking this simple theory one step further, you can easily make stunning panoramic prints up to 30in (76cm) in length, even with the most basic of desktop inkjets. The process works by setting a custom paper size in the printer software settings, a size that you dictate and one that is easily saved and stored for future print-outs. All printers have a maximum length of paper that they will accept in their Custom size settings, most varying between 24 and 36in (60 and 91cm) long.

The finished print

The image prints exactly in the centre of the paper.

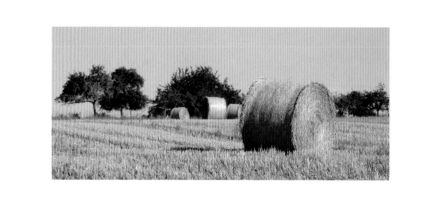

1 Starting point

If you want to print on your own cut-down paper, you need to make a custom paper size. Get your image ready to print, then do a File>Print command.

2 Customize

In the printer's Paper Size pop-up menu, click on the Manage Custom Size option and this will take you into the next dialogue.

3 Set the dimensions

Measure the cut paper and then click the tiny '+' icon to create a new size. Give it a name, then enter the exact dimensions of the paper, as the printer will use these figures to place the image in the centre of the paper.

4 Select the custom size

The custom size will now be available to select from the Paper Size pop-up menu, ready to make your final print.

4

Print *formats*

PRINT PREVIEW

Working out exactly how an image will appear on paper can be a confusing issue for many digital photographers. To make things simpler, Photoshop has several Print Preview options available for you to use.

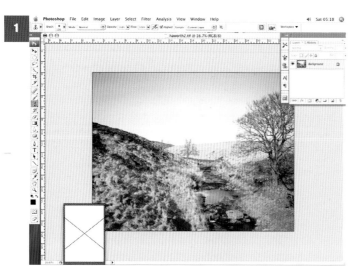

1 Pop-up method

At the bottom left-hand corner of the image window is a tiny panel that, when clicked, displays a preview of the image as it will print on the current paper size. This symbol means that the image is too big for the current A4 paper.

2 Better fit

After changing the paper size to A3, the pop-up preview now displays the image in its entirety. This will now print within the space of the available paper.

1 Print dialogue method

You can also modify the position of the image on the paper in the Print dialogue. Show Bounding Box option allows you to resize by pulling any corner of the image.

2 Change orientation

By clicking the tiny page icon underneath the print preview, you can easily change the orientation of the print from portrait to landscape format.

Using Lightroom

In Lightroom's Print module there is an extensive range of tools for positioning and resizing an image for print-out. On the left is the Template Browser panel, where you can select a preset print shape, or save your own design.

87

SIMPLE BORDERS

If your digital photos lack a bit of punch when printed out, try adding a border to make them look more effective. Like conventional photographic prints, digital inkjet prints can look washed out if there's a bright area at the edge of the image that blends into the paper base colour.

1 Starting point

Complete your creative image editing and do this stage just before printing. Organize your desktop with the Navigator, so you have blank grey space around the image. Next, do a Select>Modify>Border command.

2 Setting the size

Next, set the border size when prompted by the dialogue box. Aim for a small border to start with, with a 20 pixel value.

3 Set the border colour

With the border selection still active, do Edit>Fill. When the dialogue box appears, choose a colour from the pop-up menu. For this project, black was used at 100% opacity.

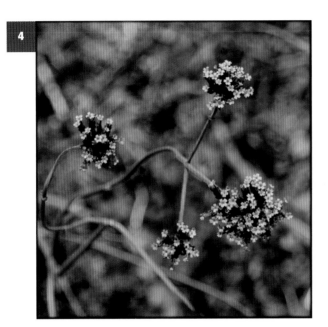

4 Finished print

The border is now complete and adds a three-dimensional edge to the image.

Hints *and* Tips

You can also produce a simple black border around your image in the Print dialogue box. Click on the Border button and when prompted, set the value at 2–5mm. This is a function of the printer software, so the border won't become permanently embedded in your image file when you return to your desktop.

COLOURED MOUNTBOARD

When your eye is drawn to an empty space, especially one that is as bright as the surrounding paper, it can look as if the image is slipping off the page. Not all digital photos are meant to be darkened down at the edges, so a good compromise is to add a thin border which contains and frames the image inside the paper print.

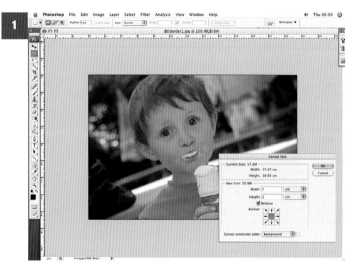

1 Canvas size

Make sure the background colour is set to white, then make a grey space around the image with the Navigator. Next, do Image>Canvas Size, then increase both width and height by 2cm. Press OK.

2 White border

The command has created a plain border around the image by effectively adding new white pixels to the file. The next step is to add a further border in a darker colour around the outside.

3 Darker border

Click on the Color Picker and set a new background colour by using the dropper to sample a colour from the actual image, in this case a midtone brown. Return to the Canvas Size dialogue and increase width and height again, this time by 4cm.

4 The final print

Set with two new borders, the final print looks stylish and the border colours complement the image.

TEXTURED PAPERS

If you want to make a digital print that has the look and feel of a watercolour print, but without the hassle of using soggy and unpredictable media, you can always cheat a little by using Photoshop's layer blending modes.

1 Scanning textures

Choose an interesting piece of paper and place it on your flatbed scanner. Capture in RGB mode and make a high resolution scan big enough to output at A3. Set the scanner input resolution to 300dpi and leave all contrast controls alone.

2 Open in Photoshop

Next, pick an image that has obvious highlight areas, as these will allow the paper texture to show through. Simply copy and paste the photographic image on top to create an extra layer. The two images won't be the same size, so use the Transform tool to scale down the photographic image until it sits in the middle surrounded by a border, as shown.

92

3 Blend together

After repositioning this new layer, change its Layer blending mode, found in the dropdown menu at the top left of the Layers palette, from normal to multiply. This has the immediate effect of discarding all highlights that are lighter than the underlying textured paper layer. Now both paper images should be merged perfectly together.

4 Final print

Notice how the image highlights allow the paper texture to show through. Print on a watercolour paper.

OVAL MOUNT

An oval mount is an ideal way to conceal unimportant image details and has been a firm favourite with photographers since Victorian times. The best way to make an oval mount is to use Photoshop's Save Selection commands.

1 Make an ellipse

The hardest part of this project is making the oval itself. Use the Marquee tool and do a Shift+Alt drag to create a circle anywhere in the image. Next, do Select>Transform Selection and pull the handles until you create an oval shape.

2 Save the selection

With the oval selection still active, do Select>Save Selection and give your selection a recognizable name. This is then stored invisibly in the Channels palette as an outline, ready to be recalled when it is next needed.

3 Cut away the excess

With the selection still active, do a Select>Inverse command to select everything else in the image. Do Edit>Cut and watch how the surrounding pixels are cut away, leaving a clean oval shape.

4 The outer mount

To create a coloured outer border, do Select>Load Selection to bring back the saved outline. Next, do Select>Transform Selection and make the shape slightly bigger than before. Then press OK.

5 The finished print

Click on the Color Picker and set the background colour to brown. Return to the image with the selection still active and do Edit>Cut. The outer white will now be replaced with the brown, creating the effect as shown.

MAKING A VIGNETTE

If you want to mimic the look of a bygone era, try adding a vignette to a family portrait. Making a soft-edged oval frame around a portrait is a well-established darkroom technique that was used as far back as the 1850s. The shape, called a vignette, was used to remove any unwanted background details and draw emphasis onto the main portrait subject.

1 Making the shape

The vignette is easy to create using the Elliptical Marquee tool. If you can't get the right shape around the subject, then the best way to use the Elliptical Marquee tool is to draw a simple oval, then pull it into shape using the Transform Selection tool.

2 Fine-tuning

Select>Transform Selection puts handles on the edges of the oval selection, so you can pull it into the exact shape. Unlike Edit>Transform which will move pixels, Transform Selection will only work on the selection outline, leaving the image untouched.

3 Soften the edge

Next do Select>Inverse to flip the selection to the outside. Apply a soft edge by a Select>Modify> Feather command. Make the Feather Radius 20–50 pixels to create a gentle, soft edge that bleeds into the background.

4 Cutting

After feathering, do Edit>Cut and watch how the unwanted background is replaced with the current background colour, set to default white.

5 Cropping

Recompose the image using the Crop tool. Leave a generous white border around the vignette or the print will look cramped.

MAKING A PANORAMIC

Composing digital photographs through a tiny viewfinder window can be a very hit-and-miss affair, but that's when the Crop tool really comes in handy. Designed to work like a traditional photographer's pair of L-shaped masks, the Crop tool lets you recompose an image to make a tighter, more dynamic fit.

1 The Crop tool

Just like sawing off the edges of a chessboard, the Crop tool removes pixels from an image to make it smaller. It is great for trimming off untidy edges and altering the entire shape of an image from a dull old rectangle into a more dynamic panoramic.

2 Reshaping the image

Drag the Crop tool across the image. Don't worry about making an exact crop, as you can pull the tiny handles until it's right. Only the area inside the dotted line will be retained. When you are happy, press Return to commit to the crop.

3 Print-out

Do File>Print and make sure that the new panoramic image shape fits into the chosen paper. In this example, the image was printed out on a sheet of A4 paper.

4 Finished print

Trim the print paper as shown and you will have a perfect postcard.

Hints *and* Tips

The Bounding Box control in the Print dialogue box also allows you to position the image anywhere on the paper. Make sure the Centre Image option is deselected, then simply drag and drop the image anywhere on the page.

MAKING A POSTER PRINT

Confusingly, Canvas Size is always the same size as Image Size, unless you decide differently. Canvas is really a term used for generating additional blank space around an image, which can then be used for adding type, graphics or more images in a poster project.

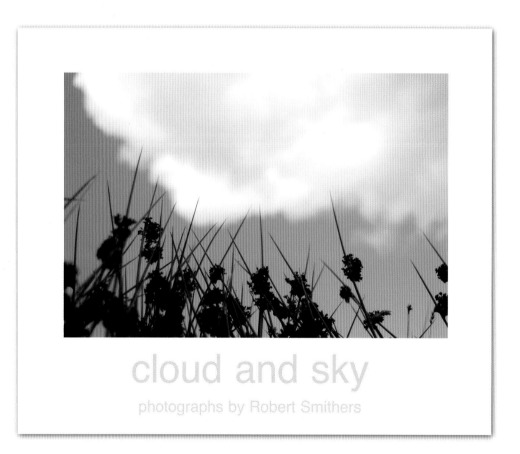

cloud and sky

photographs by Robert Smithers

New canvas space is made from new pixels whose colour is defined by the current background colour and will increase the file size. The exact place where new canvas appears is determined by the Anchor icon found in the Canvas Size dialogue box. If new canvas is created with a colour and set to appear equally around each side of the image, this can be used to create a quick and effective border.

1 Increase the Canvas Size

There's an easier way of increasing the Canvas Size of an image, without using the Canvas Size dialogue. Use the Crop tool and drag it around the edge of the image. Next, pull the handles outward until you create new space outside the image.

2 Decide on the shape

Use the Crop tool again to reframe the image, making top, left- and right-hand borders all equal, but leaving the bottom border deeper. The deep bottom border will be used to accommodate the text.

3 Create new layer

Do Layer>New Layer and drag this under the image layer in the Layers palette. Next, do Edit>Fill and fill it with white, to create the white paper border around the image.

4 Add type

Use the Type tool to enter text onto your design. Keep the text colour grey or another midtone, so it doesn't take emphasis away from the main image. In this example, a second, smaller line of type was added.

101

MAKING A CONTACT PRINT

Viewing a contact print is the first step of editing your images after a shoot. Here, you can decide which images to delete and, most importantly, which ones to print. All imaging applications can make variations of the contact print, so you can contemplate your decisions away from the workstation.

1 Using Photoshop

Do File>Automate>Contact Sheet II and, in the Source Images section, click Choose to identify the folder of images. Next, choose the print size and thumbnail layout and watch the tiny grey print preview take shape. Press OK and watch the automated action produce a perfectly neat file ready to print.

2 The contact print

With the Use Filename as Caption option, you can easily identify the file on the print. If there are more files than will fit on one page, Photoshop simply makes another.

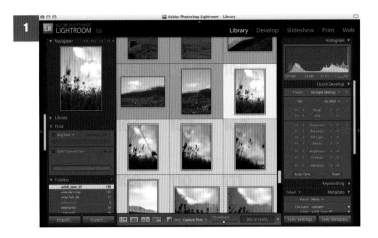

1 Using Lightroom

In the Library module, arrange your files into three thumbnails per row. Next, change each file into portrait or landscape views as shown, and delete any images that you don't want to keep.

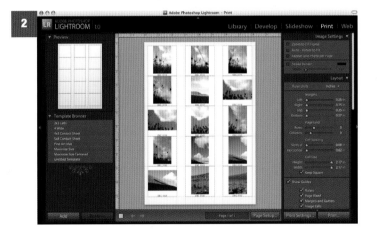

2 The Print module

In the Layout menu, found at the right-hand edge of the Print module, set the Page Grid, Cell Spacing and Cell Size, as shown. This creates a live print preview. When complete, press Print.

Using iView Media Pro

Many photographers use the versatile iView Media Pro application as a simpler browser compared to Adobe Bridge and as an alternative presentation program to Powerpoint. You can also make contact prints from iView, by doing a simple Make>Contact Sheet command.

MAKING MULTI-PRINTS

If you're an expert at shooting family photographs then you'll be constantly making enlargements and duplicate prints. Nowadays, with the advent of clever photo manipulation software, you can easily print out the same image more than once on a single piece of paper.

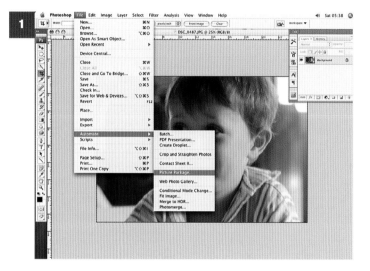

1 Automate command

Do File>Automate menu, to find the Picture Package command. The command works on either a folder of images or a single image file and creates a brand new document, ready to print or save for another day.

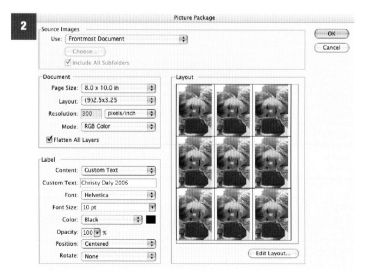

2 Picture Package

Multiple print-outs are a great way to make invitations, business cards or mini postcards without having to stand over your printer as they emerge on single sheets. There are over 16 different packages from which to choose.

3 Print and cut-out

Choose a stiff paper to print on if the individual images will be cut into smaller sizes. A heavier paper, such as Epson Photo Glossy, is ideal for this project and will prevent tearing. Once dry, cut the sheets using a rotary paper cutter, rather than scissors or a scalpel, as this will give a clean edge without posing any risks.

Hints *and* Tips

For adding a caption, date or message to the print-outs, the Picture Package allows you to call up any text previously created in the File Info dialogue or to write a new caption. Unfortunately, the caption can only be placed within the image itself, rather than in a border outside the image, which may compromise your composition.

brighton1.tif

MAKING CUT-OUTS

There's no reason why you can't strip an object away from its background and make something a bit more interesting. If you have the patience to create a complex selection edge around an element in an image, you can make really eye-catching cut-outs.

Final image

This final print was made from three separate object scans on a flatbed. Both tools were cut out and laid on top of a textured wooden background before Layer Effect drop shadows were added to create a 3D appearance. The image was finally toned to unify the colours.

1 Scan the object

Using a flatbed scanner, make a scan of an object at 300ppi. This will ensure there is sufficient detail for a good print.

2 Use the pen tool

With the pen tool, start clicking points around the image, following the edge of the shape as tightly as possible.

3 Save as a path

Join the last point to the first; then in the Paths menu save the outline. This is now saved and stored for future use.

4 Cut away the background

Turn the path into a selection and do Select>Inverse, then Edit>Cut to remove the background. It's now ready to use.

MAKING A MASK MONTAGE

If you have shot a lot of images and can't decide which is the best one to print, why not create a montage of the best? This technique uses simple masks in Photoshop, which work like stencils, allowing only parts of the whole image to show through.

Final print

Four different images were combined in a simple grid-like montage.

1 Choose the source images

Open up the image browser and choose four images to use for this project. Open all four images in Photoshop, ready to copy and paste into a new document.

2 Map out the new document

Do File>New and create a document 12x12cm. Next, drag horizontal and vertical guides to the centre to create four equal squares. Use the Marquee tool to select the squares.

3 Paste into the mask

With the selection still active, do Edit>Paste Into and watch how the image appears inside the square. Use the Move tool to position the image behind the mask.

4 Complete the montage

Draw another square selection and repeat Step 3 a further three times. The Layers palette should look like the example above, with the masks showing as tiny, white/black icons.

MAKING A JOINER

*Shooting a big subject out on location often presents problems of
scale, viewpoint and the restrictions imposed by the wrong type of lens.
This simple Photoshop technique combines several source images into
one single file, which better captures the nature of the original subject.*

Three source images
Shot in a narrow New York street with a long lens, these three images can easily be combined.

The finished print
Knitted together, the
three source images blend
together well to create a
wider view of the original
scene with no visible joins
at the edges.

110

1 Increase canvas size

Open the middle image in the joiner. Use the Crop tool to drag across the whole image, then pull the left and right edges outwards until you have tripled its width.

2 Paste in the source images

With the Layers palette open, copy and paste the source images in and arrange them in place, as shown. The Layers palette will now show three layers, one for each source image.

3 Transform and position

Use the Move tool to push a source file into the best-fit position. Then, using the Edit>Transform tool, position the cursor on the corner and rotate the image until it matches. If there are areas that still don't fit, try using the skew tool to manipulate them into position.

4 Adjust contrast

Each source file was exposed in-camera differently; to correct the imbalances, use the Levels dialogue to match the two outer layers to the centre. As you move the highlight and midtone sliders, the images will now start to blend together, forming a perfect fit.

VELVET CASE

You can easily mimic the look of a historic photographic print by reusing a discarded decorative border or case. You can easily find these and once they have been scanned, they provide unique borders for your images.

The original starting point

This old velvet case was a little damaged and had lost its print, but proved to be an interesting border for the project.

1 Make a scan

Place the object face down on the scanner and make an RGB scan at 600ppi.

112

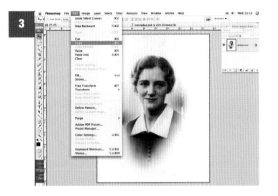

2 Crop and select

Use the Crop tool to remove the unwanted areas, then select the empty black area with the Magic Wand.

3 Copy the original

When the image is ready to insert into the frame, do an Edit>Copy command.

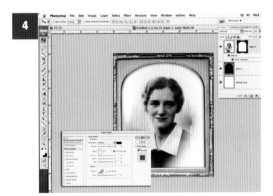

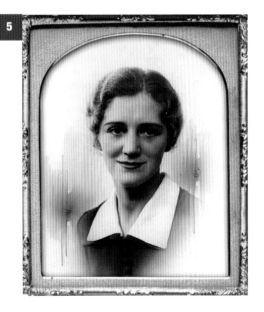

4 Paste in

With the selection still active, do Edit>Paste Into and use the Transform tool to position the image inside the decorative frame. Do Layer>Layer Styles>Inner Shadow and move the direction of the shadow until it gives the impression of the image sitting behind the frame. This will complete the illusion.

5 The finished print

Complete the project by printing out on cream-based watercolour paper to maintain the period feel.

5

Printing
colour styles

VIVID COLOUR

When digital cameras save and store your files with compression, colours are often much more muted than you expect. However, you can restore the vibrance of your original scene by following a simple Photoshop routine.

1 Bland beginnings

Straight out of the camera, this shot looks bleak and uninspiring.

2 Brighten up the highlights in levels

Move the highlight slider to the left, as shown above.

3 Increase saturation

Open the Hue/Saturation dialogue and from the Edit menu, choose the Reds option to restrict the saturation increase to this colour only. Next, move the saturation slider +20/30 until the colours start to look more vivid.

4 Fine-tuning

Complete the edit by opening the Color Balance dialogue. Warm the image up by increasing the amount of yellow in the midtone area of the image, as shown above.

Hints *and* **Tips**

When making saturation commands, always turn on the View>Gamut Warning option first. Colours that won't print with the same intensity as viewed on screen are tagged a silver colour, as shown on the red door.

5 The finished print

Compared to start of the project, the final print looks much more visually interesting.

SINGLE COLOUR TONING

A traditional darkroom technique is the application of a chemical toner as the final printing sequence to replace colourless monochrome with a wonderfully rich tint. Blues, sepia and purple-red selenium were all favourites of the darkroom magician and are still very much in demand today.

1 Hue/Saturation

Shot in the early morning this image lacks any tonal emphasis. To improve the shot, use the Hue/Saturation controls to make an all-over tonal effect which removes colour altogether.

2 Colorize command

Do Image>Adjustments >Hue/Saturation. When the dialogue box appears, click on the Colorize button. The image will immediately take on a single colour tint, but you can change this by moving the top hue slider.

118

3 The finished print

Like traditionally toned photographic prints, it's much better to produce a delicate end result rather than a full-on vivid image. You can reduce the intensity of the tone by moving the saturation slider to a value between 10 and 25. Aim for a weak but suggestive colour.

Using Lightroom

More advanced toning controls are available in Adobe Lightroom, where you can apply more than one colour to the image at the same time for a richer visual effect.

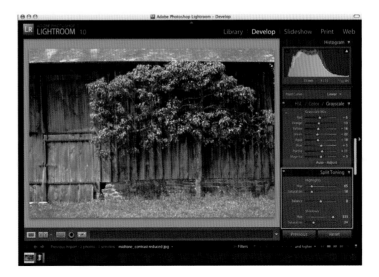

MONO STYLES

Monochrome prints stand out in an exhibition and can put your work a cut above the rest. Great for sensitive and timeless portraits and even better for rugged landscape work, the world of mono is making a comeback in digital photography.

1 Starting off

This colour image is interesting enough, but can be made mono in several ways, each with a different end result.

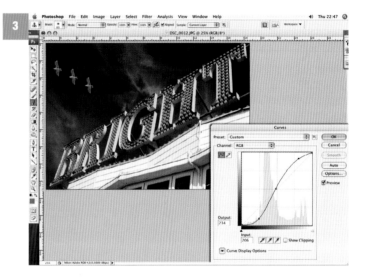

2 Desaturate

The simplest method is Image>Adjustments> Desaturate, but the end result looks muddy and a little disappointing.

3 High contrast with an S-shaped curve

The Curves controls are the most effective way to manipulate tone in an image. To mimic the look of a high-contrast print, drag the curve into a gradual, italic style 'S' shape as shown. As the shape develops, notice how the darker areas in the image start to intensify and how the lighter parts become brighter. The steeper the 'S' shape, the more contrast you will create. As with all Photoshop dialogue boxes, if you decide you have gone too far, simply press the Alt key, then press the Reset button when it appears in the dialogue.

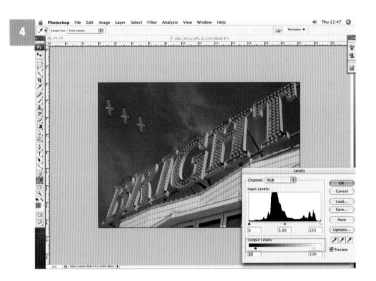

4 Low contrast

To make a low-contrast print, open the Levels dialogue. Next move the two Output Levels sliders slightly nearer the centre, as shown left. This reduces the intensity of both highlights and shadows to create a low-contrast image.

5 Using the Black and White dialogue

Photoshop's recently introduced Black and White dialogue box offers several presets for creating eye-catching monochrome conversions. This punchy example below was created using the Maximum Black preset.

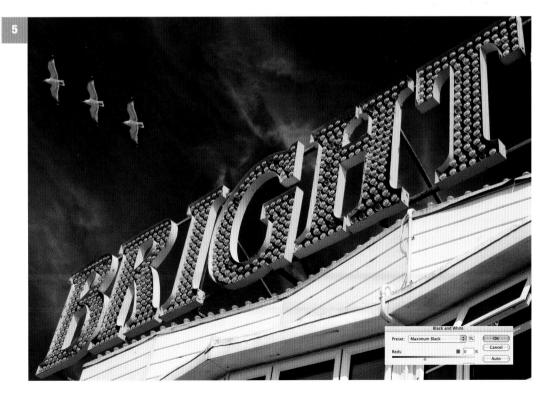

121

GRAINY DOCUMENTARY

Film-shooting documentary photographers have long enjoyed producing grainy print styles. Today's digital cameras are so sophisticated that grain is now a thing of the past, yet with a crafty use of a Photoshop filter, you can easily re-introduce it to your prints.

1 Starting point

This evocative image was shot with a digital camera, then split-toned to create a vintage print feel. The colour image now looks timeless and would be difficult to date.

2 Select the filter

Ensure you have completed all your contrast and creative processing first and only apply the grain filter just before printing out. In Photoshop select the filter by doing Filter> Artistic> Film Grain.

3 Fine-tuning controls

In the Preview dialogue, set the filter controls as shown left. Choose maximum intensity and set the Grain size at 3 for a visible effect. Press OK.

4 The finished print

The final print looks gritty and film-like and really helps to convey the subject.

COLOUR AND MONO MIX

Using a simple digital processing routine you can combine the best bits of colour and monochrome in a single image. The following technique uses Photoshop's innovative History Brush tool to seamlessly mix past and present states of an image together.

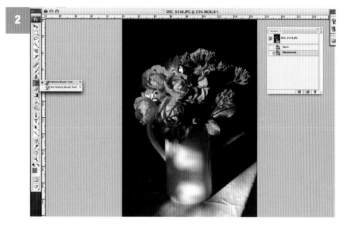

1 Starting point

Start off with an image in the RGB mode.

2 Drain the colour away

Do Image>Adjustments>Desaturate to drain the colour away then pick the History Brush from the Toolbox.

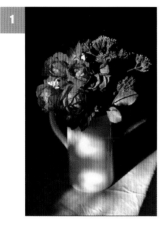

3 Set the History state

Open the History palette and click on the previous state of your editing, as shown circled in blue. Next, set the History Brush size to a large 200 pixel size, with a soft edge. This will make the brushwork less noticeable.

4 Vary the opacity

To achieve a gradual brushwork effect, reduce the Opacity to 60%. This means you will paint back a less saturated version of the colour, which will help to blend in with the monochrome elements.

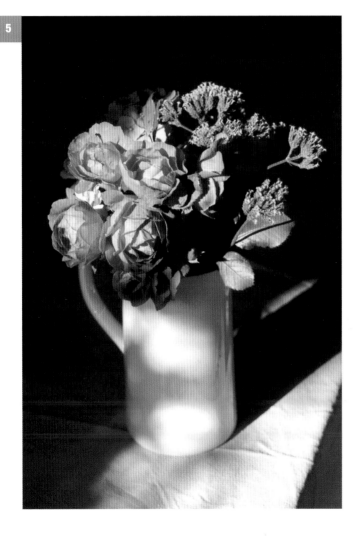

5 Finishing point

The final version of the image blends the RGB colour starting point with a monochrome state into a completely different kind of print. With this technique, less painting results in a much stronger end result.

VICTORIAN VINTAGE

Many historic family photographs have been damaged beyond repair due to poor handling, storage and excessive exposure to daylight. Yet, after a high resolution scan, most physical damage can be elimated using Photoshop's Clone Stamp tool and some sensitive colouring.

1 Scan and assess the damage

This original print was severely damaged after being ripped in half, but further harm was created when adhesive tape was applied on top! To fix the problem, scan the print on flatbed, in the RGB colour mode set at a super high resolution of 600ppi, to produce plenty of fine detail to work with.

2 Clone away the damage

Start the resuscitation by draining all the original colour away with Image>Adjustments>Desaturate. This will make the next step easier and allow you to add a new colour later on. Choose the Clone Stamp tool and gradually stamp away the physical damage, a tiny bit at a time. Use a variety of brush sizes to work on fine and larger details and ensure that you keep changing the clone source sample point to prevent any tell-tale herringbone patterns appearing.

3 Stamped out

After removing most of the damage, the image is now ready to colour.

4 Colorize

Open up the Hue/Saturation dialogue and click on the tiny Colorize button found at the bottom right-hand side. Next, use the Hue and Saturation sliders to apply a vintage colour effect.

5 The final print

With a warmer colour and a little extra burning-in of the background, the finished print puts back more detail and texture than was present in the original.

GRADUATED FILTERS

On return from an inspiring shoot, there will always be an inevitable number of files that are missing the wow factor. Pale white or washed-out sky tones never do your original subjects justice, but they can easily be renovated with a gradient filtering routine.

Before

The original image was shot at noon but the sky reproduced paler than expected. With such a large expanse of same-colour blue in the image, the introduction of a graduated filter would make it more interesting.

After

With a careful applied graduated effect, the new purple colours blend seamlessly into the original blues. Be cautious in the amount of new colour that you apply, as a small increase will often be enough to transform the original.

1 Select the gradient type

Select the Gradient tool, then click on the Gradient picker pop-up menu and choose the foreground to transparency option. If you can't see it, click on the pop-up menu and do a Reset Gradients command.

2 Choose the gradient colour

With the Dropper tool, sample the darkest colour in the sky to make a realistic base colour for the gradient. Next open the Color Picker and press the Arrow Down on the keyboard to make the sampled colour slightly more saturated.

3 Set the blending mode

Click on the tool's blending modes and select one of two options. To convert clear white skies to blue choose the multiply blending mode and a 40% opacity. To make light blue skies more saturated, choose the colour blending mode at 100%.

4 Apply the gradient

Position the gradient tool at the top of the image, click and then drag the tool downwards until you have reached the bottom of your intended area. This will produce a clean band of colour which will sit inside the area that you have defined.

HAND-PAINTED EDGES

A great way of making hand-painted edges without a Photoshop plug-in is to draw them yourself. After scanning and combining with an image, they make unique and effective borders for your prints.

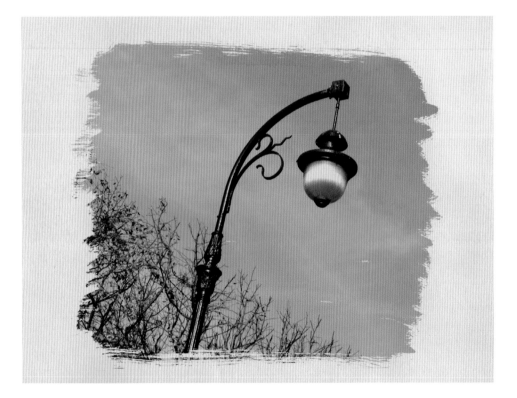

The finished print

Showing the jaggedy ink-splashed edges that were created in this project.

1 Scan in the paper

To start with, scan in a sheet of cream artists' paper as a 300ppi RGB.

130

2 Make and scan the shape

On an A4 sheet of paper, drag across a dry, fat-bristle brush loaded with black paint. Wait for this to dry, then scan at 300ppi to create the outline shape for the project.

3 Select the rough-edged shape

In Photoshop do Select>Color Range and increase the Fuzziness to maximum. This will ensure the shape is selected.

4 Paste in the image

Open up the image you'd like to use for the project and do Edit>Copy. Click back into the rough-edge image window and with the selection shape still active, do Edit>Paste into. Use the Transform tool to scale it correctly. Finally do Layer>Flatten Image edit.

5 Set the layer blending mode

Open the scan of the artists' paper, then copy and paste it into the rough edge image and make it the bottom layer. To complete the project, alter the layer blending mode to Multiply, as shown, to lose the whites in the image and merge the layers together.

PHOTOGRAPHIC BORDERS

There's really no reason why all photo prints have to be rectangular in shape, with predictable straight edges. If you want to make your prints look more eye-catching, try using PhotoFrame Pro, the creative plug-in for Photoshop and Photoshop Elements.

1 Starting point

Make all essential contrast and colour adjustments to the file before loading it in the plug-in. Next, do OnOne>PhotoFrame Pro to launch the plug-in.

2 Choose a border effect in PhotoFrame Pro

Click View Frame Grid to preview different borders.

3 Modify colours

This example shows a black Acid Burn edge applied to the image. To change the properties of the edge, do Window>Show Background. Here, you can change size, colours, shape and sharpness.

132

4 Fine-tuning

Surrounding the image on each edge are four tiny handle icons, similar to Photoshop's cropping tool. Pull and push these until the border overlaps the image correctly. When complete, press the Apply to New Layer button.

5 The finished print

By applying the border onto a new layer, the new effect is kept separate from the original starting point. The final result looks much more interesting, using the Film Edge border, coloured white.

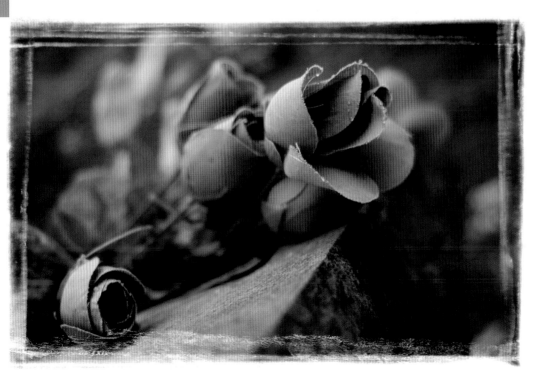

133

FOCUS BLUR

Getting the correct exposure when shooting on location is tricky enough, so it's easy to make depth-of-field mistakes. However, you can easily correct distracting backgrounds by using Photoshop's creative Lens Blur filter.

Before

Like most subjects shot on location, there is only a short amount of time to make the exposure before the composition opportunity has gone. In this image, the wrong aperture value has created a distracting sharp background.

After

By using one of Photoshop's blur filters, it is easy to mimic the effects of lens blur, without looking false or over-edited. Without the background vying for visual attention, the main foreground subject is now much more evocative.

134

1 Starting point

To create the effect, start by doing a Layer > Duplicate Layer command, as shown above in the Layers palette. Next, turn off the duplicate layer and make the background layer active for Step 2.

2 Quick Mask

To protect the areas that need to remain sharp, select the Quick Mask mode at the base of the toolbox and the Gradient tool. Drag the Gradient until it creates a gradual red protective area, as shown. Next, click out of Quick Mask mode.

3 Lens Blur filter

Do Filter>Blur>Lens Blur and open the full screen dialogue as shown. The Quick Mask area will protect parts of the image from blurring, so you can use the sliders to create the desired amount. Just a slight blur will be enough to make the edit look convincing.

4 Blend the layers together

After completing the Lens Blur command, return to the Layers palette and switch the duplicate back on. Make this the active layer. Finally, change the blending mode to Hue, as shown above, to merge both blurred and sharp layers together.

TEXTURE FILTERS

Like their real-world counterparts, software filters can make an image look clichéd, if used without forethought. However, combined with a clever use of blending techniques, Photoshop's texture filters can make your image much more eye-catching.

1 Starting point

Choose an image that would benefit from the addition of a texture, such as this example. Next, open the image and use the Navigator to make space on the desktop around the edges.

2 Texturizer window

Do Filter>Texture> Texturizer and wait for the image to fill the preview window. Next, choose the Sandstone texture and increase both Scaling and Relief until the texture becomes evident in the image.

3 Fade filter

Immediately afterwards, choose Fade Texturizer from the Edit menu. This gives you the option of lessening the impact of the filter effect by using blending modes and Opacity. Reduce the Opacity to 50–60%.

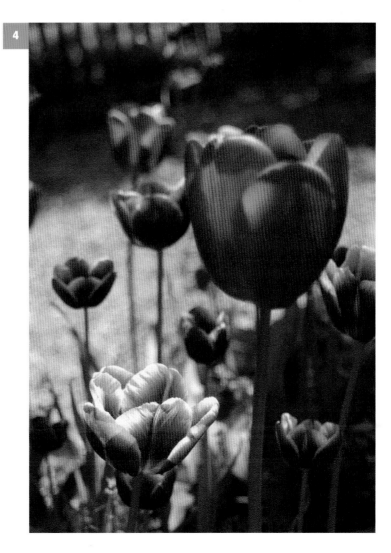

4 Finished print

By using a faded application of the texture filter, the resulting print looks much more appealing. With a built-in texture, this kind of result is best printed onto an off-white matt media, such as Somerset Velvet Enhanced.

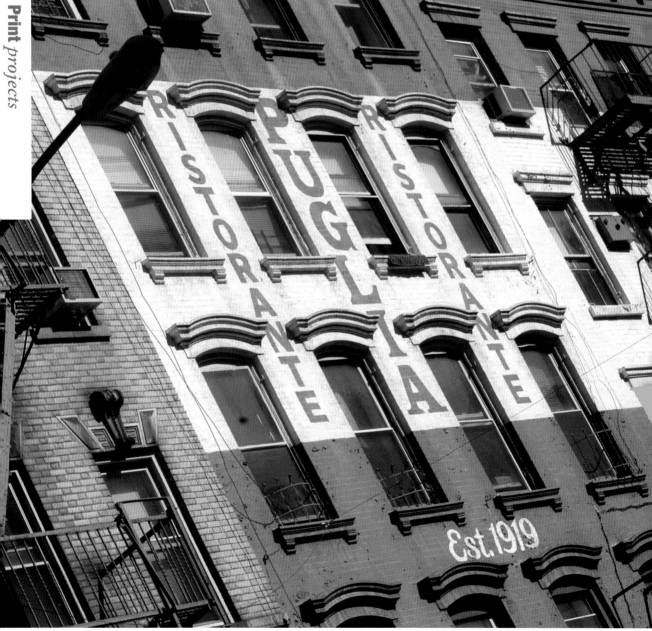

6
Print
projects

CALENDAR

A calendar is a special way of making your best shots into a functional print-out that will entertain your family and friends for a year. With many online photo-labs offering free design templates, there's little sense in spending time laying out a calendar in a desktop publishing programme.

1 Design online

Online digital service providers, such as Lulu.com, have a simple calendar wizard that you can follow step by step. Identify your best 12 images, plus an extra one for the cover and you're ready to start.

2 Upload your files

Prepare your image files so they need no further contrast or colour adjustments and save as high quality JPEGs for faster upload. The images need to be in a horizontal or landscape format to fit the page shape.

3 Check before ordering

The Lulu.com service provides a very useful preview function, so you can check the positioning of your images on each page. The web-based service creates a high resolution PDF file which acts both as a downloadable preview for you to look at and a print-ready format to store and send to print when ready.

4 Making changes

The step-by-step wizard also creates the text element of the calendar design for you, based on the year that you choose as a starting date. Your uploaded images are squeezed into place and positioned to avoid the spiral binding strip at the top edge. The online service provider also acts as a shopfront for your product, selling and distributing to any visitor you direct to your own personal page.

INKJET BOOK

Many photographers are now choosing to print their own portfolios at home. The do-it-yourself inkjet book offers an economic way to prepare a stunning one-off book of your work or personal project.

1 Fine-tune your images

Organize your chosen images into a set and a sequence, so you know exactly where they appear in the book. With an inkjet book kit, you can add or remove individual pages, so you can alter the content without ruining the binding.

2 Custom print size

All book kit pages will be cut to a specific size, so it's worth first creating a custom print size to match. Make a new size in the printer software dialogue and remember to also include space for the thicker left edge which gets bound into the book spine.

3

3 Print out

Most good products such as Innova and Hahnemuhle book kits provide profiles with their products, so you can get top quality results with an inkjet. It is a good idea to buy some extra leaves in case you make a mistake.

4 Bound and ready to view

The Innova post book kit, below, provides a simple method of binding individually printed pages through two screw post fittings. These can be easily removed and new leaves inserted if you want to change the contents too.

4

143

CANVAS PRINT

If you want to output on a larger than usual scale, then a canvas print is an ideal way to immortalize an image. Specially made coated inkjet canvas is available for most desktop printers and there are many online labs offering canvas output and mounting.

1 Starting point

Do Edit>Adjustments>Curves. Next, drag the curve into a gentle sloping 'S' shape, as shown left, to slightly increase the contrast. Printing onto a heavily textured surface will always reduce contrast, so this is a good way of keeping control.

2 Select media type

With specialized printing media such as canvas, it's essential to choose the right media type and the correct media feed option. For this example, the Textured Fine Art paper proved best, together with the Manual Feed for such a thick type of printing media.

144

3 The finished print

This uncluttered image, shot with a minimum of sharpness, proved to be an ideal subject for a canvas print, where the texture enhances the subject without spoiling it.

Cheating with Photoshop

You can avoid the expense of special media by using the Texturizer Filter in Photoshop to apply a similar effect. Use the Canvas texture to apply a delicate weave to the image.

ON-DEMAND PHOTO BOOK

The very latest on-demand technology is driving a revolution in personalized book design. On-demand services such as Blurb, offer a cost-effective way for you to design and sell your own book without any upfront costs.

1 Register first

Look up service providers to see what book formats, page sizes and binding options they offer. Both Blurb.com and Lulu.com offer great value and quality output. Next, register and create your own upload area.

2 Lay out the pages

Prepare the image files in Photoshop as Tiffs and use a DTP program like InDesign or QuarkXpress to create a simple document, as shown left. On-demand printers also provide free templates or downloadable layout software for you to use instead.

3 PDF upload

Most on-demand book printers ask for the final layout document in a PDF format, as shown left. Saving in this format ensures that fonts, images and layout remain locked in position throughout upload and output.

4 Publish and sell

Once uploaded, the book is ready to order and to sell to others. Like Amazon, most on-demand service providers will also sell your title online for you. Online payment, post and packing is all taken care of, leaving you free to carry on being creative.

Hints *and* Tips

If photographs are the means by which you communicate rather than words, then keep the cover design simple. This example, right, uses colours sampled from the image to create the title colours.

GREETINGS CARD

Special occasion cards can be expensive to buy in the shops, but very simple to make with an inkjet printer and a sheet of quality media. This project uses the useful drag-and-drop feature of Photoshop's Print dialogue box, which enables perfect positioning.

1 Starting point

This image was first prepared in Photoshop by boosting the colour saturation and contrast so it printed well on watercolour-type inkjet paper. Greetings cards need to be produced on thicker media so they can be self-supporting when folded.

2 Orientation and size

When the image is ready, select File>Print>Page Setup, so you can choose the paper size and orientation. This card will be A5 in size once folded, printed on a single A4 sheet.

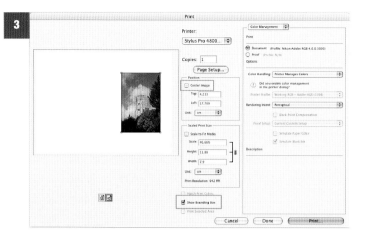

3 Drag and drop

In the Print dialogue, deselect the Center Image option and choose Show Bounding Box. Drag the image into place to the right half of the paper as shown, to allow for the fold.

4 Folded and finished

Text can also be added inside the card by repeating Steps 1–3 with the same sheet of paper, using the rear side to print out on. To avoid buckling the printing paper, leave it to dry first before folding. Thick paper folds better if it is scored slightly, using a blunt craft knife or blade.

BUSINESS CARDS

If you're looking for a stylish way to promote your business or service, then a photographic card will really do the trick. The most innovative product is available from on-demand printing provider Moo, where you can print 100 stylish mini cards from different image files.

1 Starting point

Log into www.moo.com and register as a new user. This will enable you to download templates and upload your final design for print-out. Choose the mini-card service, as shown on the left.

2 Download a template

To get the image to fit the product's dimensions, it's best to download a template with cropping guides. With any commercial print project, you must allow some margin of error in the cutting stage, shown here by the non-printing guides.

3 Upload your designs

Save images as JPEGs, then upload them to your account area through your browser. At this stage you can determine how many copies you require from each design, or even rotate files to fit the business card shape.

4 Add text on the reverse

Moo offers a very simple method of entering text on the reverse side of the card, as shown left. Although there are limited fonts, colours and styles, both type size and text positioning is automatic, so you can't make it unreadable!

Hints *and* Tips

Business cards are not the same shape as your digital images. Choose landscape format images that can afford to be cropped top and bottom.

CD INSERT

Archiving your best images onto removable media is very good practice, but knowing which files are on which disks is another matter altogether. Improve your retrieval skills by printing covers and contact prints to fit CD cases.

Contact Sheet II

1

Source Images
Use: Folder
Choose... library:images:tuscany 07:
☑ Include All Subfolders

Document
Units: cm
Width: 13.8
Height: 11.8
Resolution: 200 pixels/inch
Mode: RGB Color
☑ Flatten All Layers

Thumbnails
Place: across fi...
Columns: 5
Rows: 6
☑ Rotate For Best Fit
☑ Use Auto-Spacing
Vertical: 0.035 cm
Horizontal: 0.035 cm

☑ Use Filename As Caption
Font: Helvetica Font Size: 8 pt

OK
Cancel

Press the ESC key to Cancel processing images

1 Starting point

To make a contact print at exactly the right size to fit a rear CD case, do File> Automate>Contact Sheet. In the Document panel, set the width and height as shown left. Next, opt for five columns and six rows, to keep the images large enough to be recognizable. Select the Filename as Caption option, so you can see the document name underneath each thumbnail. Finally, choose the source folder of the images, then press OK.

Hints *and* Tips

CD insert measurements

CD front cover aperture measures

4⅞ x 4⅝in (12.5 x 12cm)

CD rear cover aperture measures

5⅞₆ x 4⅝in (13.8 x 11.8cm)

2 Rear CD insert

This example shows a custom-sized contact sheet inserted into the case, with 30 tiny thumbnails and their filenames underneath. Labelling disks like this can help you to track down the source files quickly and easily.

3 CD cover with bleed

For a single image front cover, you need to create a new empty document. Do File> New and change the document dimensions to width 12.5cm and height 12cm, with a resolution of 200ppi. Open the source image and do Edit>Copy, then Edit>Paste. Next do Edit>Transform tool to fit the image into the cover shape.

4 CD cover full-frame

To create this effect, you need to follow Step 3, but avoid cropping with the Transform tool. Instead, reduce the size of the image until it fits inside the shape in its entirety, leaving a small border at the bottom of the document. Use the border to add a title, date or other text-based information.

153

WATERCOLOUR PRINT

Not all prints look best pin-sharp on glossy photo paper. Make your landscape images into stunning watercolour prints by using a special Photoshop plug-in and a sheet of textured inkjet paper.

1 Starting point

The following process adds contrast to an image, so it's essential to keep this to a minimum at the start. Choose an image that has plenty of open sky or other space which is not sharply detailed, like this example shown left.

2 Filter first

Use the Navigator to position the image with a visible grey border on the desktop. Then, to create the appearance of watercolour brush texture, do a Filter>Artistic> Watercolour command.

3 Modify the texture

In the preview window, zoom in so you can see the size and quality of the texture created by the filter. Experiment with the Brush Detail and Texture sliders until it looks like this.

4 Use PhotoFrame plug-in

After filtering, open the image in PhotoFrame to apply the brush-effect edge. PhotoFrame has a set of watercolour-effect edges ready to drag into position. The effect is shown below.

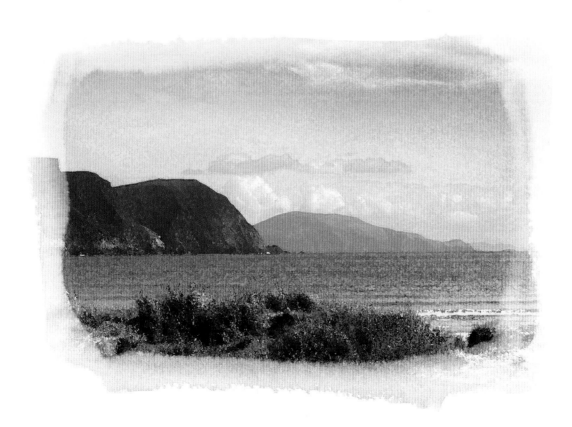

Troubleshooting
and resources

IMAGE FILE ERRORS

Despite the host of functions and features in Adobe Photoshop and your camera's on-board software, mistakes are easily made. Compare your difficult-to-print files with these common image file errors.

Low resolution

Digital cameras often allow you to capture images in a number of different low resolutions such as 640x480 and 800x600. These small files are perfectly acceptable for onscreen and web use, but make poor quality print-outs. Always shoot at the highest resolution, such as 3000x2000, which will provide enough pixels per inch for a pin-sharp print.

Low quality JPEG

To increase the capacity of a digital camera's memory card, many photographers shoot medium or low quality JPEGs, which create much less data. However, the downside to this space saving is a reduction in image quality. The example shown above has been made even worse: it has been re-saved as a low quality JPEG in Photoshop.

High ISO and noise

When shooting in ultra-low light conditions, the sensor in a digital camera responds to the absence of light by creating pixels of a random colour. This gritty pattern is called noise and is mostly created in shadow areas of an image. Once created in-camera, it's difficult to edit out, but Photoshop's Noise Reduction filter should help.

Index image mode

Colours that appear blocked out and posterized are caused by saving an image as a low quality GIF, or converting to Index image mode.

Corrupted file

When files are transferred from camera to computer or across a network, they can easily be corrupted. Fix with a data recovery application such as Norton.

Blown highlights

Images put through a long editing sequence can easily be overcooked. Keep your editing to as few stages as possible to avoid highlight detail blowing out.

Unsharpened

Straight from the camera, image files won't print with maximum detail unless they are first processed with the Unsharp Mask Filter. Start with Amount 50, Radius 1 and Threshold 1.

Over-sharpened

Images are often slightly unsharp and need tweaking with the Unsharp Mask Filter. This image has been over-sharpened, using Amount 250, Radius 10 and Threshold 1.

Filled-in shadows

Excessive use of the Levels or Curves controls can make vital shadow details disappear. Use Adjustment Layers to control contrast without causing damage to the file.

PRINTING ERRORS

Despite the user-friendly nature of all printer software, knowing why a print looks poor can be frustrating for digital photographers. The following sample prints display the most frequent kinds of errors caused by settings and ink issues.

Wrong media setting 1

If you combine the use of absorbent watercolour paper with a media setting for glossy paper, you will always get a dark, muddy print. Printer software media settings match the amount of ink sprayed onto the paper with its coating. The highest quality media can take lots of ink, but uncoated paper works best with much less.

Wrong media setting 2

When glossy, photo-quality media is printed out under a setting meant for matt or plain paper, the results will be washed out and speckly. Glossy media can accept the finest inkjet dots and lots of saturated ink. This example is a pale end result, which can also occur if you print out on the wrong or uncoated side of the paper.

Over-enlarged

Both Photoshop and printer software offer you the ability to increase a print size regardless of the original resolution of the image file. This example above has been over-enlarged, resulting in a complete loss of sharpness. This is caused by a high number of newly introduced pixels that create the blurred effect.

Poor quality inks

Third-party and dye-based ink can fade within a matter of months. This example has been exposed to sunlight and has lost its magenta and yellow dyes.

Ink runout during print

If this effect appears on your print, it can only be caused by one ink colour running out mid-print. On this example, the yellow ink ran out creating a clear line.

Black tank empty

Black ink runs out quickly and will leave your print looking like this. The result looks faded and lacks the illusion of depth and three-dimensional space.

Yellow tank empty

This example shows a print made with an empty yellow ink tank. This has a profound effect on other image colours, making prints look 'moonlit'.

Magenta tank empty

Leaving both cyan and yellow inks to dominate, the lack of magenta ink will create this kind of print-out. Prints will look greenish and cold.

Cyan tank empty

Cyan is the equivalent of kingfisher blue and creates depth and contrast in a print. If the cyan tank has run empty, this reddish print-out will occur.

SHOOTING ERRORS

Although most shooting errors can be corrected in Photoshop, the more severe the mistake, the fewer creative opportunities you will have with your software. Always aim to make perfect exposures in-camera, as this will help to make the highest quality digital prints.

Underexposure

Underexposure is caused by a shortfall in the amount of light received by the image sensor in the camera. When shooting on manual exposure setting, it can be easy to underestimate the amount of light required. Dark images can be corrected in Photoshop: use the midtone slider in the Levels dialogue box until details become visible.

Overexposure

Overexposure is caused by too much light reaching the sensor in your camera. This kind of error is easily made when shooting in low-light conditions, as the camera meter tries to compensate for the lack of light. Dark, atmospheric scenes are often captured lighter than expected, especially when shooting with automatic metering modes.

Metering error

High-contrast subjects or scenes present the biggest problem for a camera meter. This example has an ultra-bright tree right next to a deep black shadow and is impossible to capture in one file. A good alternative is to make three different exposures and combine them together with a high dynamic range application such as PhotoMatrix Pro.

Lens flare

Never shoot into the sun, especially if your camera doesn't have a lens hood. Flare is caused by light entering the lens at all angles, creating honeycomb shapes.

Dirty lens

Greasy fingermarks smeared on a camera lens can result in irregular white areas on an image. In this example, look at the pale patch in the blue sky.

Dust on sensor

Physical obstructions such as dust or hair can easily stick to an image sensor, creating black marks. Avoid leaving the lens off your camera body.

Aperture error

Too small an aperture can cause more elements to be in focus than you expect. Shooting at f/16, rather than f/4, has rendered a nearby fence sharper than the photographer intended.

Autofocus error

Most cameras lock autofocus on the most central aspect of a subject, regardless of your creative intentions. Lock focus first on your main subject by half-depressing the shutter-release button.

Camera shake

If you handhold your camera and use a shutter speed under 1/125th of a second, your own body vibrations can cause camera shake and the image will be slightly blurred.

163

SPECIAL OUTPUT SERVICES

For large-scale exhibition prints, point of sale posters or information panels, you will need to use a professional output lab. Always seek advice on the best way to prepare your image file to avoid making an expensive mistake.

Silver-based printing

Digital image files can also be printed out on a special large-scale device like the Lambda, shown above. This kind of device 'beams' your digital image file onto conventional silver-based photographic paper, which is then processed and dried in photographic chemistry. Large-scale Lambda prints exhibit exceptional quality and sharpness and have the added advantage of extended lightfastness compared to an inkjet print.

Wide-format inkjet

Built with the same internal printer parts and ink delivery mechanism as a desktop inkjet, large format devices can print out up to 60 inches wide. With this increase in capability comes a significant increase in running costs, so a better option is to source your large prints from a specialized photo lab. Large format printers such as this Epson Stylus Photo Pro are capable of producing photo-quality prints at colossal sizes. Many labs run large-scale devices like this using a third-party continuous ink system (CIS), hooking the printer head up to large reservoirs of ink.

This keeps running costs down to a minimum and avoids ink running out mid-job. Originally designed to produce large-scale information panels for exhibitions and marketing events, the latest wide-format inkjets can also use pigment inks and archival papers to produce gallery quality output. The wide-format printer is designed to use paper supplied as both high capacity rolls and individual sheets and it also comes equipped with an internal guillotine to cut custom-sized prints as they are completed.

SUPPLIERS

Adobe Photoshop

Adobe Photoshop and Adobe Lightroom are two key products used for the processing and creation of digital images.
www.adobe.com

Apple computers

The pro photographer's choice of desktop computer system, equipped with the fastest processors. Can now run Windows OS too.
www.apple.com

Blurb.com

Like Lulu, but offering a free downloadable book design application called Booksmart. Blurb produce exceptional quality portfolio books too.
www.blurb.com

Epson inkjet printers

The inkjet printer brand leader, Epson printers are used universally by professional photographers worldwide.
www.epson.com

Harman inkjet papers

Makers of the super quality baryta-based inkjet papers, Harman media is used by photographers seeking the highest quality media.
www.harmantechnology.com

Innova papers

Manufacturers of a wide range of inkjet papers and inkjet book kits, Innova materials are well worth trying out.
www.innovaart.com

Lulu.com

Online on-demand book printer and bookstore, Lulu.com has emerged as a firm favourite amongst photographers and artists.
www.lulu.com

Lyson inks

Makers of Small Gamut inksets and special pigment inks for desktop printers. Also manufacturers of continuous ink systems
www.lyson.com

Moo.com

An innovative UK-based on-demand printing service, providing top quality products for self-promotion and marketing.
www.moo.com

Nikon camera systems

Designers and manufacturers of the most innovative professional camera systems and lenses, renowned for their backwards compatibility.
www.nikon.com

OnOne software

Makers of PhotoFrame and Genuine Fractals Photoshop plug-ins, two very useful creative additions to your workstation.
www.ononesoftware.com

Permajet media

Makers of a wide range of digital output media, including photo papers, art papers and transparency media.
www.permajet.com

Photobox

One of the best online photo-labs, with a reputation for quality and low prices. Provides free online storage and public gallery features.
www.photobox.co.uk

Secol

Makers of archival products for preserving and presenting digital artwork including polyester print sleeves and museum clamshell boxes.
www.secol.co.uk

Silverprint

Reseller of all specialized photographic materials, both digital and traditional. Holds an extensive stock available for online ordering.
www.silverprint.co.uk

Somerset paper

Creators of Somerset Velvet Enhanced, the 100% cotton, acid-free inkjet paper, used by many photographers for exhibition printing.
www.inveresk.com

Tapestry pro lab

Professional services lab, providing high quality output in a wide range of different media. Used by many top photographers.
www.tapestry.com

X-rite profiling hardware

The market leader in profiling equipment for monitors, printers and data projectors, all supplied with simple step-by-step software.
www.xrite.com

GLOSSARY

Artefacts

By-products of digital processing such as noise and JPEG compression, both of which will degrade image quality.

Aliasing

Square pixels can't describe curved shapes and when viewed in close-up they look like a staircase. Anti-aliasing filters, found between the camera lens and image sensor, lessen the effects of aliasing by reducing contrast, which has to be put back during image processing.

CCD

Stands for Charged Coupled Device. It is the light sensitive 'eye' of a scanner and 'film' in a digital camera.

Clipping

Clipping occurs when image tone close to highlight and shadow is converted to pure white or black during scanning or exposure in camera. Loss of detail occurs.

CMYK image mode

Stands for Cyan, Magenta, Yellow and Black (called K so it is not confused with blue). It is an image mode used for litho reproduction. All magazines are printed with CMYK inks.

Colour space

RGB, CMYK and LAB are all kinds of different colour spaces, with their own unique characteristic palettes, but also limitations in their reproduction of colour.

Compression

Crunching digital data into smaller files is known as compression. Without physically reducing the pixel dimensions of an image, compression routines work by creating a smaller string of instructions to describe groups of pixels, rather than individual ones.

Curves

Curves are a versatile tool for adjusting contrast, colour and brightness by pulling or pushing a line from highlight to shadow.

Dithering

A method of simulating complex colours or tones of grey using few colour ingredients. Close together, dots of ink can give the illusion of new colour.

Dropper tools

Pipette-like icons that allow you to define colour selection and tonal limits such as highlight and shadows by directly clicking on parts of the image.

Dye sublimation

A kind of digital printer that uses a CMYK colour infused dry ink sheet sheet to pass colour onto special printing paper.

DPOF

Digital Print Order Format is a set of universal standards allowing you to specify print-out options directly from a camera when connected to direct printing units such as Epson's Picture Mate range.

Duotone

A duotone image is made from two different colour channels, chosen from the colour picker used to apply a tone to an image. Used to create subtle toned monochrome images.

Driver

A small software application that instructs a computer to operate an external peripheral like a printer or scanner. Drivers are frequently updated but are usually available for free download.

Dynamic range

The measure of the brightness range in photographic materials and digital sensing devices. The higher the number, the greater the range. Professional scanners and media are able to display a full range from white to the deepest black.

File extension

The three- or four-letter/number code that appears at the end of a document name, preceded by a full stop – for example, landscape.tif. Extensions enable applications to identify file formats and enable cross-platform file transfer.

File format

Images can be created and saved in many different file formats such as JPEG, TIFF or PSD. Formats are designed to let you to package images for purposes such as email, print-out and web use. Not to be confused with disk formatting.

Firewire

A fast data transfer system used on current computers, especially for digital video and high resolution image files. Also known as IEEE1394.

Gamma

The contrast of the midtone areas in a digital image.

Gamut

Gamut is a description of the extent, or range, of a colour palette used for the creation, display or output of a digital image. Used by Photoshop in the Gamma Warning control.

GLOSSARY

Greyscale

Greyscale mode is used to save black-and-white images. There are 256 steps from black to white in a greyscale image, just enough to prevent banding to the human eye.

Highlight

The brightest part of an image, represented by 255 on a 0–255 scale.

Histogram

A graph that displays the range of tones present in a digital image as a series of vertical columns.

ICC

The International Colour Consortium was founded by major manufacturers to develop colour standards and cross-platform systems.

Interpolation

All digital images can be enlarged, or interpolated, by introducing new pixels to the bitmap grid. Interpolated images never have the same sharp qualities or colour accuracy of original, non-interpolated images.

JPEG

JPEG is an acronym for Joint Photographic Experts Group and it is a universal kind of file format used for compressing images. Most digital cameras save images }as JPEG files to make more efficient use of limited capacity memory cards.

Lab image mode

A theoretical colour space – i.e. not employed by any hardware device – used for processing images.

Levels

A common set of tools for controlling image brightness found in Adobe Photoshop and many other imaging applications. Levels can be used for setting highlight and shadow points and for correcting camera exposure errors.

Megapixel

Megapixel is a measurement of how many pixels a digital camera can make. A bitmap image measuring 1800x1200 pixels contains 2.1 million pixels, made by a 2.1 megapixel camera.

Pigment inks

A more lightfast inkset for inkjet printers, usually with a smaller colour gamut than dye-based inksets. Used for producing prints for sale.

Pixel

Taken from the words PICture ELement, a pixel is the building block of a digital image, like a single tile in a mosaic. Pixels are generally square in shape.

Profile

The colour reproduction characteristics of an input or output device. This is used by colour management software to maintain colour accuracy when moving images across computers and input/output devices.

RAW

A generic term for the file formats that are produced by different digital cameras, which retains flexibility in some shooting parameters.

RGB image mode

Red, Green and Blue mode is used for colour images. Each separate colour has its own channel of 256 steps and pixel colour is derived from a mixture of these three ingredients.

RIP

A Raster Image Processor translates vector graphics into bitmaps for digital output. RIPs can be both hardware and software and are used on large format printers to maximize the use of consumables.

Selection

A fenced-off area created in an imaging application like Photoshop, which limits the effects of processing or manipulation.

Shadow

The darkest part of an image, represented by 0 on the 0–255 scale.

Sharpening

A processing filter that increases contrast between pixels to give the impression of greater image sharpness.

TFT monitor

A Thin Film Transistor monitor is the flat-panel type of computer screen.

TIFF

Tagged Image File Format. A format that is the most widely used by professionals as it is compatible with both Macs and PCs. A layered variation also exists, but this is less compatible.

Unsharp mask (USM)

This is the most sophisticated sharpening filter found in many applications.

USB

Stands for Universal Serial Bus. This is a type of connector that allows easier set-up of peripheral devices.

White-out

In digital images, excessive light or overexposure causes white-out. Unlike film, where detail can be coaxed out of overexposed negatives with careful printing, white pixels can never be modified to produce lurking detail.

CREDITS

Further information on digital printing

Tim Daly also runs Photocollege, the online learning centre for photography and photo-imaging.

Photocollege provides online tuition for a wide range of photographers and creative industries professionals on topics including colour management, digital printing, Lightroom and Photoshop.

Visit the website on: www.photocollege.co.uk
Contact the author by email on: timdaly@photocollege.co.uk

Thanks to

The author would like to thank the following family and friends for their invaluable help in the research and production of this book:

Nina Daly for book design.

Chris Dickie, editor of *Ag The Journal of Photographic Art & Practice.*
www.picture-box.com

Philip Andrews, editor of *Better Photoshop Techniques.*

INDEX

INDEX

Contact us for a complete catalogue or visit our website.
Photographers' Institute Press, Castle Place,
166 High Street, Lewes, East Sussex
BN7 1XU, United Kingdom
Tel: 01273 488005 Fax: 01273 402866

www.pipress.com